SIGNALLING AND SIGNAL BOXES

Along the NER Routes
Volume 1 Yorkshire

Allen Jackson

For Ninette.

First published 2017

Amberley Publishing
The Hill, Stroud,
Gloucestershire, GL5 4EP

www.amberley-books.com

ISBN: 978 1 4456 6762 1 (print)
ISBN: 978 1 4456 6763 8 (ebook)

British Library Cataloguing in Publication Data.
A catalogue record for this book is available from the British Library.

Typeset in 10pt on 13pt Celeste.
Origination by Amberley Publishing.
Printed in the UK.

Contents

Introduction

Although the NER could be likened to the Midland Railway, it was unlike the MR in one respect – that of keeping to a fairly tight geographic area. This was Yorkshire, Durham and Northumberland, and in those areas it had a virtual monopoly. Almost the only intruder into its territory was the Hull & Barnsley Railway, which the NER absorbed before the grouping. The North British Railway also had an excursion into NER territory in Northumberland.

The headquarters of the NER was at York and the later building of 1906 is listed and is now a hotel. The original cramped layout inside the city walls of the York & North Midland station of George Hudson gave way to a magnificent station just outside the walls that is now listed and an iconic NER structure. Other major stations were constructed at Newcastle upon Tyne and Hull Paragon. Leeds City was quite impressive, but a joint station with the LNW and Midland railways.

The Royal Station Hotel at York was and is the acme of luxury and comfort. Although there were extensive carriage and wagon workshops at York, the main NER locomotive works were at Darlington. The NER was in the vanguard of progress technologically and, despite their massive reliance on and access to coal, pioneered electrified means of traction, particularly on Tyneside and south Durham.

Signal Boxes and Infrastructure on Network Rail

Introduction

The survey was carried out between 2003 and 2015 and represents a wide cross-section of the remaining signal boxes on Network Rail and Associated British Ports (ABP) at Hull to maintain the comprehensive nature of these books. Inevitably some have closed and been demolished; others have been preserved and moved away since the survey started.

Summary of Contents

North Eastern Railway (NER) Part 1

GOOLE – HULL
Goole
Goole Swing Bridge
Saltmarshe
Gilberdyke Junction
Oxmardyke
Broomfleet
Cave
Crabley Creek
Brough East
Welton
Melton Lane
Hessle Road
Hull Bridge
Hull Paragon

YORK – HARROGATE – LEEDS
Poppleton
Hessay crossing
Marston Moor
Wilstrop crossing
Hammerton
Cattal
Whixley crossing
Knaresborough
Belmont
Starbeck
Harrogate

Rigton
Horsforth

YORK – SCARBOROUGH – HULL
Strensall
Barton Hill
Howsham
Kirkham Abbey
Malton
Weaverthorpe
Seamer
Falsgrave (Scarborough)
Gristhorpe
Bridlington
Driffield
Beverley Station

SELBY AREA
Barlby
Selby Swing Bridge
Selby
Thorpe Gates
Henwick Hall
Balne
Moss
Milford
Gascoigne Wood
Castleford

North Eastern Railway (NER)
Part 1

GOOLE – HULL

Fig. 1 shows a simplified schematic diagram of the area on the banks of the rivers Ouse and Humber with connections to other areas.

The port of Goole on the River Ouse has long been concerned with the export of Yorkshire coal and a system was devised where iron tubs known as 'Tom Puddings' would be filled with coal on the Aire & Calder Navigation, chained together, and then towed to Goole on the canal where they would be discharged into sea-going ships. This system rivalled the railways until 1985, when coal traffic ceased. The Lancashire & Yorkshire Railway also accessed Goole. Goole is still a thriving port with many mostly northern European sailings.

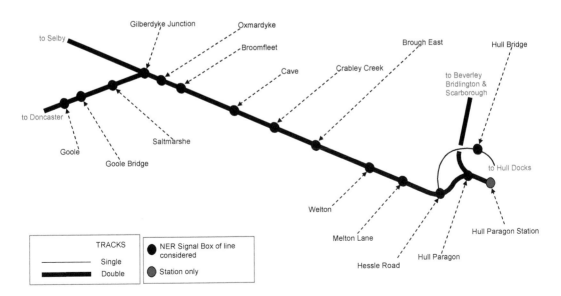

Fig. 1. NER – Goole to Hull schematic diagram.

Kingston upon Hull, to give the city its full title, was a massive fishing port as well as a major exporter of coal via the Hull & Barnsley Railway. There were major manufacturing facilities in Hull too.

Hull developed busy passenger ship traffic with northern Europe, which it maintains with roll-on/roll-off vehicle ferries.

The North Eastern Railway had one of its largest locomotive depots in Hull at Dairycoates with six roundhouses and other straight sheds.

The journey starts in a relatively modernised area and proceeds through absolute block territory with semaphore signals and nineteenth-century block equipment. The landscape is largely flat following the rivers Ouse and Humber.

Goole (G)

Date Built	NER Type or Builder	No. of Levers and/or Panel	Ways of Working	Current Status 2015	Listed Y/N
1909	NER Type S4	NX Panel	TCB	Active	N

There are still rail-connected dock facilities but the signal box here is right by the passenger station. There is no mechanical signalling here though the signal box looks fairly original, but inevitably with uPVC windows.

Goole signal box is 6 miles 51 chains (10.68 km) from Gilberdyke Junction.

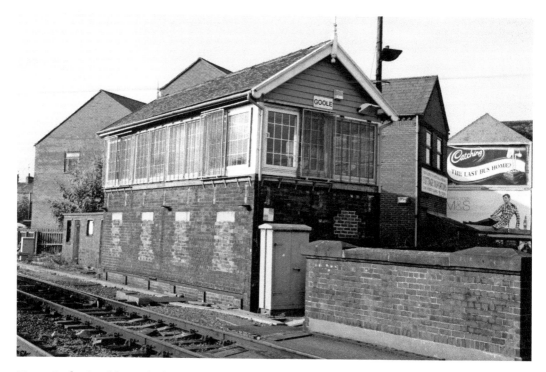

Fig. 2. Goole signal box. The bricked-up locking room windows look more like a recent security measure than a wartime expedient to reduce blast damage effects. (November 2006).

Goole Bridge (GB)

Date Built	NER Type or Builder	No. of Levers and/or Panel	Ways of Working	Current Status 2015	Listed Y/N
1869	NER Non Standard	5	TCB	Active	Y Grade I

The swing bridge signal box over the River Ouse is reputedly the oldest on Network Rail and is listed. The signal box had a panel controlling the bridge and signals, which is preserved at the National Railway Museum.

The original construction involved an early use of hydraulics where water under pressure is used to force a ram or turn a motor. The water was worked to the pressure needed by steam boilers mounted on the bridge that fed large reservoirs. With all that coal about being burned at high temperatures, it is not entirely surprising that there was a serious fire on the bridge in 1922.

In 1933, the LNER contracted Westinghouse Brake & Signal Company to install a miniaturised thumbwheel switch control panel in the bridge control room on top of the

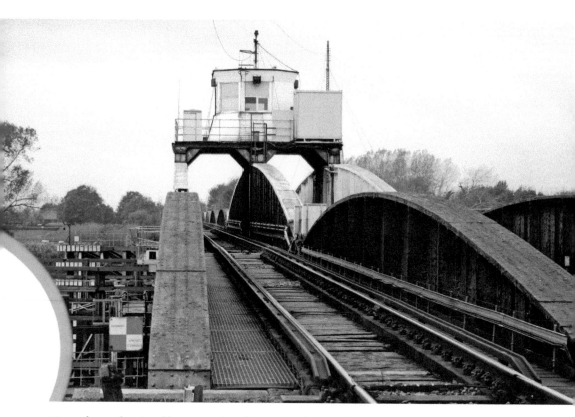

Fig. 3 shows the signal box atop the white painted moveable span. Note all the timber bulwarks on the left to deflect a shipping strike. The vaguely white painted span that has gone rusty is the bit that swings through 90 degrees to allow shipping to pass. There are run-off sidings with sand drags on either side of the bridge. (November 2006).

rotating span. Up until then there had been two conventional manual signal boxes, one on each river bank, controlling the semaphore signals. Both manual signal boxes were replaced by this panel and colour light signals were introduced on both approaches to the bridge.

The bridge has been hit many times by shipping and in 1973 the bridge was struck by the German coaster *Vineta*, which caused one of the spans to fall into the river. The bridge was unworkable for nine months. After a succession of bridge strikes wherein British Railways had been inadequately compensated, the board started proceedings for closure of the line and bridge. In 1987 the bridge was Grade I listed by English Heritage, which compelled BR to abandon closure plans as they would have to maintain the bridge irrespective of whether rail-borne traffic used it or not.

Goole Bridge signal box is 5 miles 10 chains (8.25 km) from Gilberdyke Junction.

Saltmarshe (SA)

Date Built	NER Type or Builder	No. of Levers and/or Panel	Ways of Working	Current Status 2015	Listed Y/N
1905	NER Type S2	NX Panel	TCB, AB	Active	N

An NX panel is an electrically controlled device that controls the eNtry and eXit to a piece of track. One switch is needed for the entry and another for the exit for a given

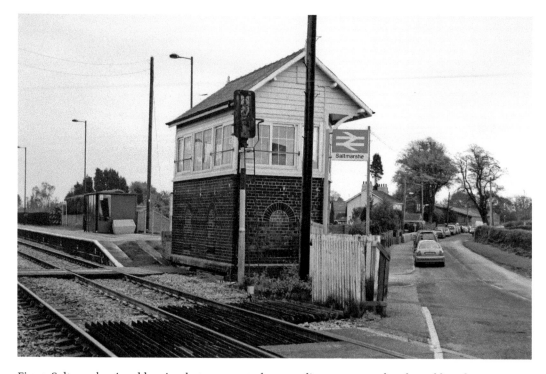

Fig. 4. Saltmarshe signal box is what appears to be an ordinary rectangular-shaped box, but one of the corners has apparently been modified to fit the road location. (November 2006).

route. The relay interlocking ensures that only the correct signal aspects are shown for any route selected.

Points and signals can still be changed with individual switches but mostly the switches are left in automatic mode. Here the route could hardly be simpler as there are no points and only a double-track main line.

Saltmarshe signal box is 3 miles 50 chains (5.83 km) from Gilberdyke Junction.

Gilberdyke Junction (G)

Date Built	NER Type or Builder	No. of Levers and/or Panel	Ways of Working	Current Status 2015	Listed Y/N
1903	NER Type S2	55	AB, TCB	Active	N

It is here that the double-tracked main lines from both Goole and Selby meet to continue their journey as one double-tracked main line to Hull. Parts of the line had been quadruple-track in the past.

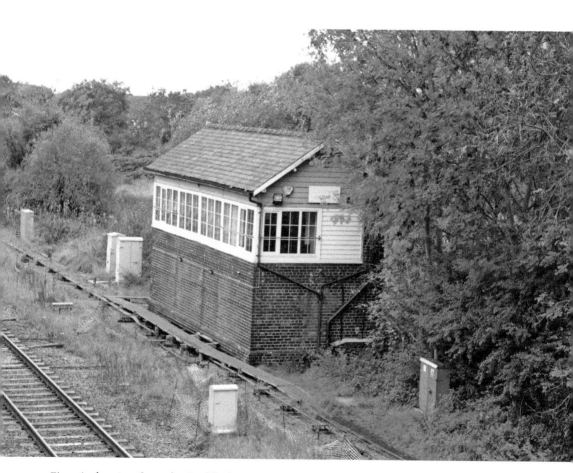

Fig. 5 is the view from the Staddlethorpe Road over bridge. The actual junction is to the left and the station and lines to Hull behind the camera. (October 2006).

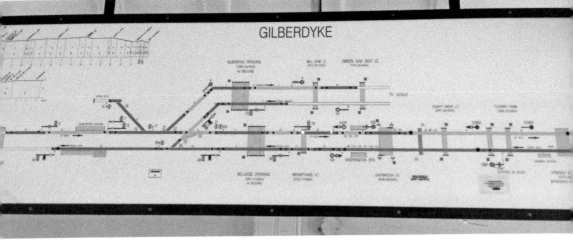

Fig. 6 is the track diagram from Gilberdyke Junction signal box, with the truncated name of Gilberdyke. The lines we have been travelling on from Saltmarshe and Goole come in from the top, and below that, on the right, is the double-track to Selby. This line continues past the box to the left of the diagram to Hull. The other piece of track is a siding labelled 'Horse Dock', although in later years it is used to park track tamper machines and other engineering vehicles. Most of the tracks are coloured in different sections and each colour change denotes a change of track section. Red lights on the diagram indicate a train occupying a track section. On the diagram a train is travelling towards Selby to the right and the rectangular blocks at the trackside represent station platforms and our train is just about to enter Eastrington station, which is just over 2 miles (3.2 km) from the box. The rectangular blocks across the tracks are crossings supervised by the box. The tracks towards the right of the diagram are the Up direction and that towards Hull and the left are the Down direction.

There are plenty of semaphore home and distant signals around the box and on towards Oxmardyke Crossing and the next block post of Broomfleet in the Hull direction. After the junction heading, to the right on both tracks, which is actually in the westerly direction, the signals go to colour lights in concert with the TCB areas the trains are entering. The gradient diagram at the top left of the picture shows us the line is mostly flat with moderate gradients. This information was necessary for signallers if a train became divided in their section and trucks (troublesome?) ran away Down a gradient. It would be handy to know in which direction vehicles were running away so that they may be diverted into a loop or siding to prevent a collision with other trains. Such accidents in the past were the cause of many lost lives. The need is not so great now that all train vehicles are supposed to be equipped with automatically operating brakes whenever a vehicle is disconnected from a train. However, there are always permanent way trolleys, which are not so equipped.

Note that the Down line crossing from Goole is a single slip, which effectively turns the junction crossing into a crossover to enable Selby trains to change tracks or reverse here. (April 2015).

The mileages change here and Gilberdyke Junction signal box is 17 miles and 7 chains (27.5 km) from the buffer stops at Hull Paragon station.

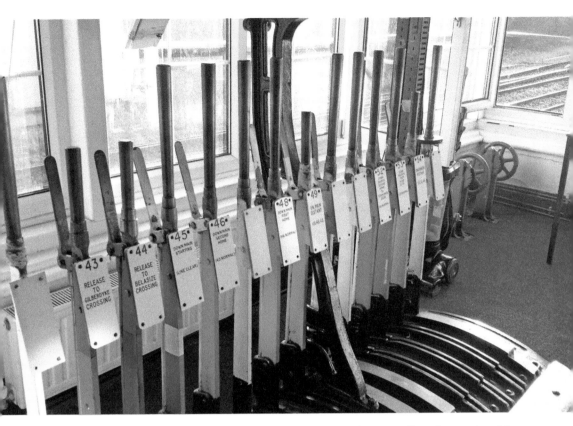

Fig. 7 is part of the 55-lever frame at Gilberdyke Junction. The two yellow distant signal levers are both colour light signals; the nearer lever number 49 is for a train coming from Selby, and lever 54 a train coming from Goole. Note that both levers are at the end of the frame that is the same as the direction the trains are coming from, i.e. from the right travelling towards Hull. This is commonplace signalling practice. The longer-levered functions are manual and the shorter are electrically operated. The blue and brown levers are to lock crossings and interlock with associated line running signals. The spare lever at the far end, number 55, has a lever collar disc parked on it. This circular disc is to remind a signaller that a lever is not to be pulled, usually as technicians may be working on that particular function. It used to be a reminder to a signaller that a train may be standing at a signal, but with the widespread use of track circuits this is not usually necessary.

The two red wheels beyond the end of the frame are signal wire adjusters used to take up the slack in a signal wire when it expands in hot weather. The mechanism adjustment has a ratchet that can be released when the weather goes back to normal.

Back in the day, when lever 49 was a semaphore distant signal, the pull needed on the lever was strenuous and the signaller would place a foot against the cast-iron bracket to gain extra purchase to make the changeover.

Lever 45, Down starter signal towards Hull, has a lead plate to indicate what must happen before this lever can be pulled, and that says 'Line Clear'. In other words, the signal cannot be pulled off or clear unless Broomfleet has selected 'Line Clear' on their block instrument and that indication is reflected at Gilberdyke. As Oxmardyke is a gate box, it has no block post facilities, but just 'listens' to what Gilberdyke and Broomfleet are doing. (April 2015).

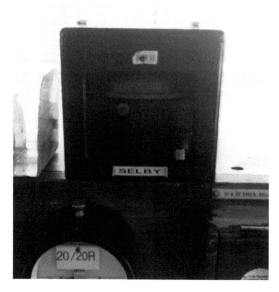

Fig. 8 is the instrument labelled Selby. As Gilberdyke Junction works TCB to Selby there is no need for any AB instruments as we have seen in Fig. 11, but there is still a need to describe trains from box to box using a block bell. The bell is the bottom section of a BR domino block instrument with a Morse tapper key to call Selby, and the bell dome to receive bell codes from Selby. (April 2015).

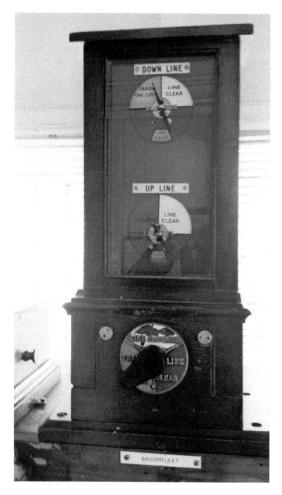

Fig. 9 is the LNER block instrument for Broomfleet. The next block post Down the line and Gilberdyke Junction has selected 'Train on Line', so the train is now in section as opposed to 'Line Clear', where it is just expected, and the train is coming from Broomfleet on the Up line.

The Down line at the top of the instrument shows that there is another train in Broomfleet's section, heading for Hull, and the signaller at Broomfleet has selected 'Train on Line', which is reflected here at Gilberdyke.

Note: It is unusual for the colours on the needle indicators to not be the same as they are on the rotary switch below. However, the switch colours are generally accepted to be correct. (April 2015).

Fig. 10 and the train on the Up line Broomfleet block arrives from that direction. First TransPennine class 185 No. 185130 hurtles past the platforms at Gilberdyke station past the box, on its way to Selby and beyond. The taller home signal is for Selby and the shorter for Goole. (April 2015).

Fig. 11 is the view the other way from Fig. 10 and DMU class 158 No. 158815 rattles over the junction from Goole to stop at Gilberdyke station. We know this because the signaller has quite rightly checked the train with the distant signal at the junction, even though the home signal on the same post is off. (April 2015).

Fig. 12 is a non-stopper at Gilberdyke station, this time from Selby. Both points in the picture have facing point locks, and while the one on the left is obvious enough for Goole-bound passenger trains, the one on the right would allow a passenger train to run up to the box on the Down line where the class 158 is and then reverse over the single slip. (April 2015).

Oxmardyke (O)

Date Built	NER Type or Builder	No. of Levers and/or Panel	Ways of Working	Current Status 2015	Listed Y/N
1901	NER Type S1a	16	Gate	Active	N

Oxmardyke was one of the select group of signal boxes that had gate-wheel-operated level crossing gates in the twenty-first century. This consisted of a complex arrangement of screw jacks and levers that enabled the signaller to open and close the gates from the box. The survey was after installation of modern barriers but before removal of the gate wheel and linkages. The locking levers remain.

Oxmardyke signal box is 16 miles and 22 chains (22.2 km) from the buffer stops at Hull Paragon station.

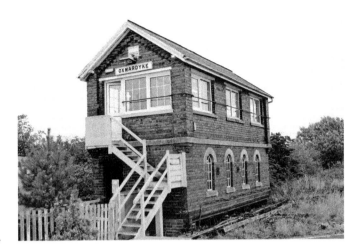

Fig. 13. Oxmardyke signal
box. Some of the linkages
to the former wooden gates
can be seen. (October 2006).

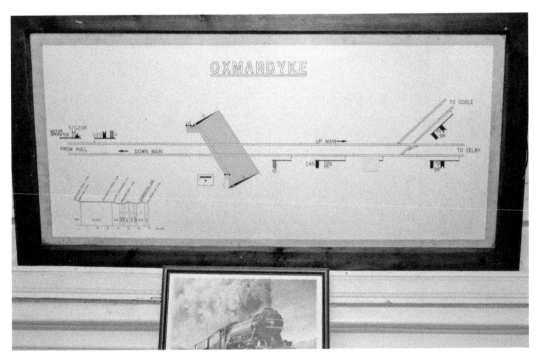

Fig. 14. Oxmardyke signal box diagram. The fact that the road crossing is not 90 degrees to the track is readily apparent. The two distant signals we saw in Fig. 11 outside Gilberdyke Junction box are repeaters for the distant signal lever No. 9 at Oxmardyke, on the Down line, which we will see in a minute. Oxmardyke is less than 1 mile (1.6 km) from Gilberdyke, so it is usual for the distant signal of one signal box to be on the same post as the home signal of another signal box if the two boxes are close together. With a line speed of 70 mph (113 km/hr), the time taken to travel between the two boxes is less than a minute and so the distant is placed to enable braking to take place if the next home signal is on or 'danger'.

To the left of the diagram, Oxmardyke's Up distant (5) is co-located with a repeater for Gilberdyke's distant (G20R), whose actual signal (G20) is further up the line to the right and is on the same post as Oxmardyke's Up home signal, No. 4. Note that there are no track circuit lights on the diagram here. (October 2006).

19

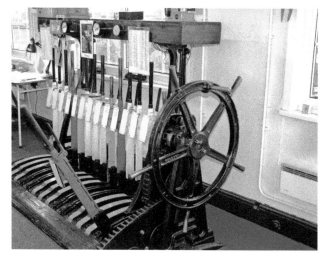

Fig. 15 is the lever frame at Oxmardyke and levers 5 and 9 are indeed distant signals; they are the cut-down version as they are motor-operated and only change over switches.

The gate wheel is in attendance; however, since the removal of the gates the only brown lever left is for the wicket gate on the far side of the road. (October 2006).

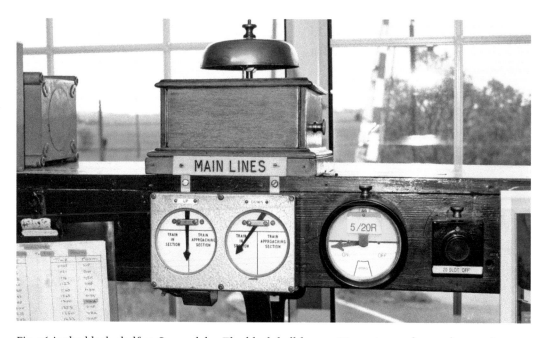

Fig. 16 is the block shelf at Oxmardyke. The block bell has no Morse tapper key and can only listen to block signals from either Gilberdyke or Broomfleet. The 'MAIN LINES' label is from the time the lines were quadruple-track. All of the instrumentation in all of the boxes would need to be duplicated for the second pair of tracks.

The two indicators fastened to the block shelf do give notice of an impending arrival and on the Down line towards Hull a train is imminent. These indications are simply taken from the 'Line Clear' and 'Train on Line' functions from the boxes on either side.

The circular instrument with the yellow colouring is the status indicator of signals 5 and 20 repeater (Gilberdyke) that we saw on the diagram. The indicator to the right of the circular instrument is a slot indicator for signal 20 repeater. This means that an electrical lock is provided to ensure that there can be no challenging indication from Oxmardyke to what Gilberdyke has selected. It is a kind of inter-box interlock that cannot be achieved in the locking frame below the box as the functions concerned are geographically separate. (October 2006).

Broomfleet (B)

Date Built	NER Type or Builder	No. of Levers and/or Panel	Ways of Working	Current Status 2015	Listed Y/N
1904	NER Type S2	60	AB	Active	N

Like many other signal boxes on this line, Broomfleet is much larger than needed presently with a double-track main line, just a crossover and no goods facilities.

Broomfleet signal box is 14 miles and 33 chains (23.2 km) from the buffer stops at Hull Paragon station.

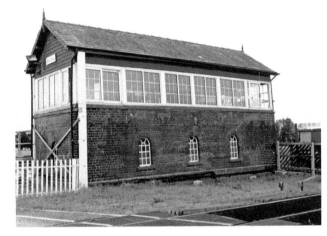

Fig. 17. Broomfleet signal box. It looks as though one end of the box would fall over were it not for the massively cross-braced steel girders at one end. (September 2015).

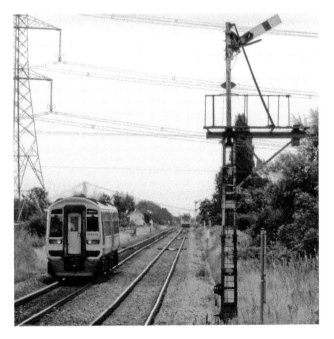

Fig. 18 is the other direction towards Cave and Hull. In fact, Cave crossing signal box is less than 1 mile (1.6 km) from Broomfleet box and can be seen in front of the class 158 DMU, No. 158908. The distant signal on the Up line coming towards the camera is off and maybe it would be on to remind the driver to stop at Broomfleet, but the Pacer class 142, No. 142049, is not stopping here. Broomfleet station has bucked the national trend and passenger numbers have halved in ten years, as only four trains a day stop here and this is not one of them. Humber Bridge is in the background. (September 2015).

Cave (–)

Date Built	NER Type or Builder	No. of Levers and/or Panel	Ways of Working	Current Status 2015	Listed Y/N
1904	NER Type S2	16	Gate	Active	N

The large village of South Cave was served by the Hull & Barnsley Railway until the 1950s, so there is no station here on the NER line.

Cave crossing signal box is a rural backwater where the signaller places the gates against the railway on request, assuming no train is imminent. This is the opposite of the usual practice at crossings, wherein the traffic flows dictate that the gates or barriers be held open for the road.

Cave signal box is 13 miles and 60 chains (22.1 km) from the buffer stops at Hull Paragon station.

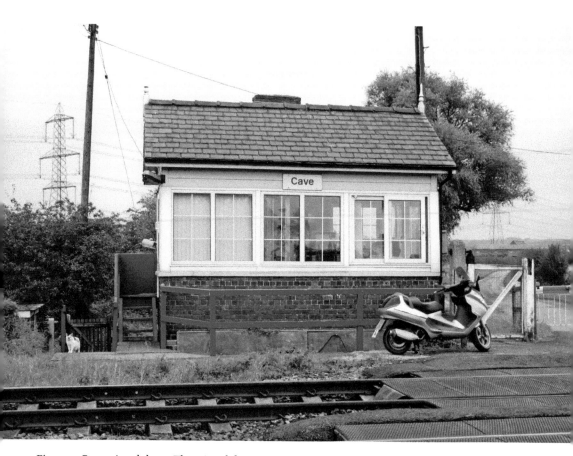

Fig. 19. Cave signal box. The signal box cat possibly senses the presence of an intruder. The sleeper-built building to the left of the gate may have been a lamp hut or fuel store. (October 2006).

Crabley Creek (CC)

Date Built	NER Type or Builder	No. of Levers and/or Panel	Ways of Working	Current Status 2015	Listed Y/N
1904	NER Type S1b	14	AB	Active	N

Crabley Creek signal box is a block post with AB responsibilities for Broomfleet and Brough East towards Hull, as well as a request crossing.

Crabley Creek signal box is 12 miles and 57 chains (20.46 km) from the buffer stops at Hull Paragon station.

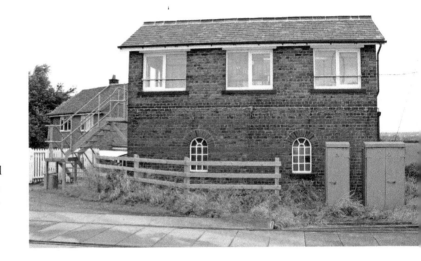

Crabley Creek signal box with plasticised upper windows and original locking frame room ones. (October 2006).

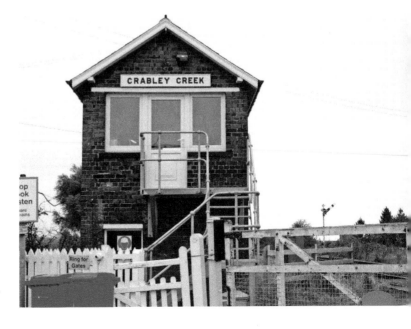

Fig. 21. Crabley Creek signal box features wooden manually operated gates as well as the bell push to summon the signaller. (October 2006).

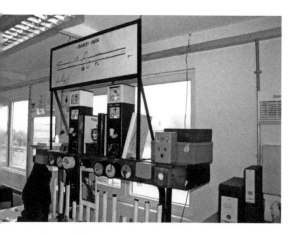 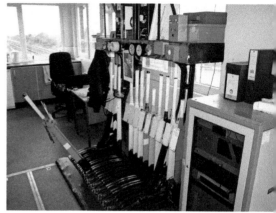

Above left: Fig. 22 is the diagram and block shelf at Crabley Creek. To the left on the diagram is towards Hull and the right Selby. The distant on the Up line towards Selby is motor operated and on the Down a colour light signal. Both home signals are semaphores and the Down is bracketed. There are two track circuits here and these are necessary to employ the Welwyn Control. The silver and white circular devices with the winding handles on the front on the block shelf are Welwyn releases, one for each track circuit. They permit a signaller to override the track circuit interlock but only after a built in time delay with the clockwork winding handle.

The block instruments themselves are the BR 'domino' type. The Brough East instrument on the left is showing 'Line Clear' and this has been selected by the Crabley Creek signaller for an Up train coming from Hull. The Broomfleet instrument on the right already shows a 'Train on Line' heading the same way on the Up and this has been selected by Broomfleet. Neither train is in section on the track circuits yet. (October 2006).

Above right: Fig. 23 is the lever frame at Crabley Creek and the Up home and the distant hiding behind it are pulled off for the train we saw on the Brough East instrument at Fig. 22. The white stripe on the red signal lever indicates there is an electrical lock on the lever as well as the lock on the frame in the locking room downstairs. No doubt this is the Welwyn Control lock with the track circuit as previously described.

There are no black point levers here but there is a black lever with chevrons and that is a detonator placer lever. Detonators are small explosive devices placed on the track that explode under the wheels of a passing train as an emergency stop signal in fog or falling snow. Although the detonator placer is now deemed too risky to use, the levers here remain. (October 2006).

Brough East (BE)

Date Built	NER Type or Builder	No. of Levers and/or Panel	Ways of Working	Current Status 2015	Listed Y/N
1904	NER Type S2	52	AB	Active	N

Brough is famous for the Blackburn Aircraft works, which became part of BAE Systems.

Brough East signal box is 10 miles and 24 chains (16.58 km) from the buffer stops at Hull Paragon station.

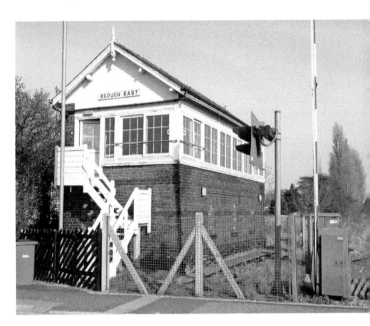

Fig. 24. Brough East signal box. Places where there are multiple signal boxes usually end up with modified names when the signal box becomes a singleton. This was not so at Brough East, even though there is no other form of Brough extant. (April 2015).

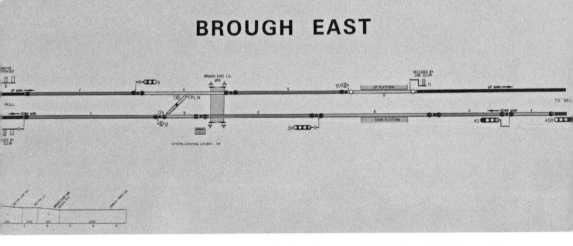

Fig. 25 is the diagram at Brough East and it has been considerably modified over the years. After the removal of the quadruple-tracks, four platforms were retained at Brough station with two bays that serviced the Hull direction, but they have now gone. The days of masses of BAE Systems workers arriving at Brough from Hull are over, at least by rail.

The top Up line has a motor-operated distant signal followed by a colour light signal then a bracket by the station platforms.

The bottom Down line towards Hull has a succession of colour light signals followed by a ground disc for reversing over the trailing crossover and then a bracketed home signal.

Both bracketed home signals are interlocked with block instruments that require 'Line Clear' to be selected before they can be pulled off. The crossover just by the box has a Facing Point Lock, which would enable a passenger train to regain the Down line to go back to Hull. There are plenty of track circuits here and one of them is occupied by a Selby-bound train at the Up platform. The ground disc – 15 on the Up line – would signal a move over the crossover. (April 2015).

Fig. 26 is the impressive lever frame at Brough East, albeit with lots of spare levers, with an equally impressive, if less populated, block shelf with only two block instruments for Crabley Creek and Melton Lane, together with their block bells. The control panel pedestal at the far end is for the level crossing barriers. (April 2015).

Fig. 27 is the block instrument to communicate with Crabley Creek. Brough East has selected 'Line Clear' on the Down line so the train is going towards Hull, but not here yet. (April 2015).

Fig. 28 is a view from almost ten years earlier with the two bay platforms and starter signals still in place. Compare this with the diagram at Fig. 25. Note the BR North Eastern Region motorised-boom-type level crossing gates. (October 2006).

Welton (–)

Date Built	NER Type or Builder	No. of Levers and/or Panel	Ways of Working	Current Status 2015	Listed Y/N
1904	NER Type S2	6	Gate	Active	N

Common Lane, Welton is yet another crossing place on the line where the traffic is light and the gates are kept closed against the traffic. The box operates similar to Oxmardyke and the crossing position makes it easy to see trains at speed on the line.

Welton signal box is 9 miles and 35 chains (15.19 km) from the buffer stops at Hull Paragon station.

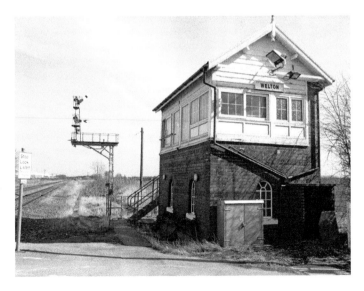

Fig. 29. Welton signal box. This shows the box complete with the original locking frame room windows. The grey motor to operate the distant signal is clearly visible below the arm on the post. (April 2015).

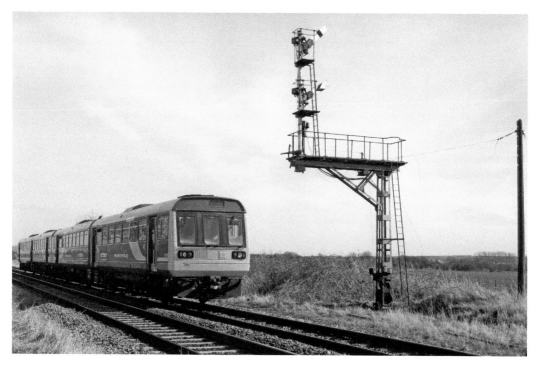

Fig. 30 demonstrates the need for investment in railways in the north as Northern Rail Pacer class 142 No. 142067 trundles Up from Brough towards Hull. (April 2015).

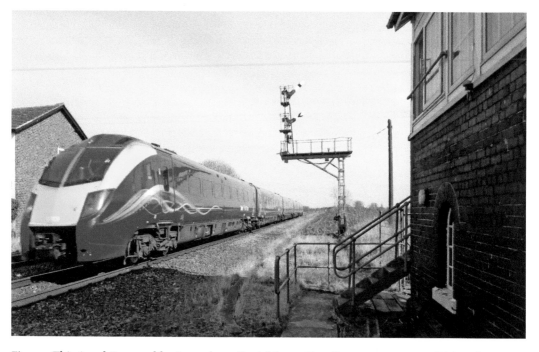

Fig. 31. This is a bit more like it as class 180 Adelante No. 180109 powers past Welton box towards Selby. (April 2015).

Melton Lane (ML)

Date Built	NER Type or Builder	No. of Levers and/or Panel	Ways of Working	Current Status 2015	Listed Y/N
1921	NER Type S4	26	AB, TCB	Active	N

Melton Lane signal box can be found at Gibson Lane, Melton, North Ferriby, so perhaps it's a case of need to know. Croxton & Garry of Gibson Lane had premises for the manufacture of calcium oxide and other powders as blends for the rubber and plastics industries. They had extensive sidings at Gibson Lane, together with a railway halt for their personnel that is now disused, but some facilities remain.

Melton Lane signal box is 8 miles and 41 chains (13.7 km) from the buffer stops at Hull Paragon station.

Melton Lane signal box in Fig. 32 has the stone lintel above the locking frame windows rather than the rounded arch, but this is later on in NER history and costs would appear to have been cut. The box retains the motorised boom gates at this earlier survey date, which look as though they have been hit by a vehicle. (October 2006).

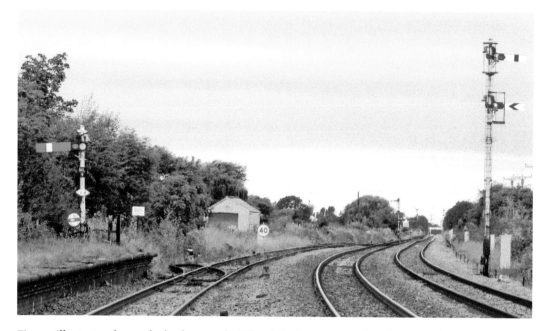

Fig. 33 illustrates the tracks back towards Gilberdyke Junction, and Welton signal box can be seen less than a mile (1.6 km) away at the centre right of the picture. Welton signal box always seems to have its Up home signal off, as here, unless the gates are open to Common Lane.

The Croxton & Garry factory complex is on the far left complete with ground discs for entry and exit to the sidings and loops. The far left-hand track is described as the Up slow line, but is actually a loop to separate Croxton & Garry (now Omya) traffic from the main lines. The platform for workers at the chemical plant is clearly visible but disused. The white bridge across the tracks in the distance is the footbridge at Brough station. (April 2015).

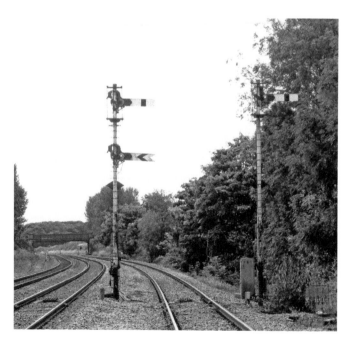

Fig. 34 is the opposite direction to the previous figure towards Hull. The signals protect the Up running lines, fast and slow. The next station along the line is Ferriby and then it's the Humber Bridge, after which is Hessle station and the site of Hull Dairycoates steam depot. (April 2015).

Hessle Road (HR)

Date Built	NER Type or Builder	No. of Levers and/or Panel	Ways of Working	Current Status 2015	Listed Y/N
1962	BR North Eastern Region Power Box	NX Panel	TCB	Active	N

Hessle Road had been a five-way double junction in semaphore days, but closures in the 1960s led to a simplified layout wherein there is a double-track main line to Paragon station, a single-track branch to Hull docks, and a double-track main line to Beverley, Bridlington and Scarborough. The box provided a release for Hull Bridge signal box, which supervised the working of the single-track docks line over the River Hull.

Hessle Road signal box is 1 mile and 74 chains (3.1 km) from the buffer stops at Hull Paragon station.

There will now be a meander up the Hull docks branch to visit Hull Bridge signal box.

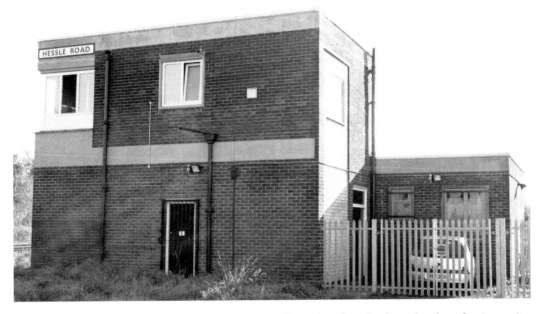

Fig. 35. The style of architecture can perhaps be described as local authority 1960s brutalism. The signal box had the 1962 NX panel replaced with an updated version in 2008. (November 2006).

Hull Bridge (–)

Date Built	NER Type or Builder	No. of Levers and/or Panel	Ways of Working	Current Status 2015	Listed Y/N
1885	Not Known	5 IFS Panel	TCB, OTS	Active	N

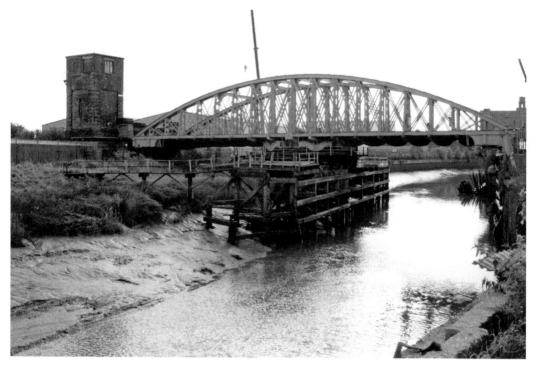

Fig. 36. Hull Swing Bridge signal box. The 1885 signal box received a partial hit from an air raid in the Second World War, so the top of the box was rebuilt in 1940 in a kind of early Air Raid Precautions (ARP) style. The box is equipped with a Saxby & Farmer lever frame. (November 2006).

Hull Bridge has had a long but relatively quiet career as the bridge is only swung open twice a day at high tide to let any ships that might be there pass through.

The box used to work OTS, or One Train with Staff, from the box to the docks and the line had originally been double-track. OTS was the system is use at the survey date in 2006. An Individual Function Switch, or IFS panel, was fitted to control signals in 1964.

The working is now TCB all the way from Hessle Road with an Associated British Ports control room at the docks, so business must be picking up.

Hull Bridge signal box is 3 miles and 76 chains (6.35 km) from Hessle Road Junction.

Hull Paragon (HP)

Date Built	NER Type or Builder	No. of Levers and/or Panel	Ways of Working	Current Status 2015	Listed Y/N
1938	LNER Type 13	NX Panel	TCB	Active	N

Hull Paragon station was built on a magnificent scale reflecting the high degree of optimism then prevalent in Victorian society. The architect was G. T. Andrews, who did much station work for the NER and more of his work is covered later in the book. The station hotel was fit for royalty and accommodated Her Royal Majesty and entourage

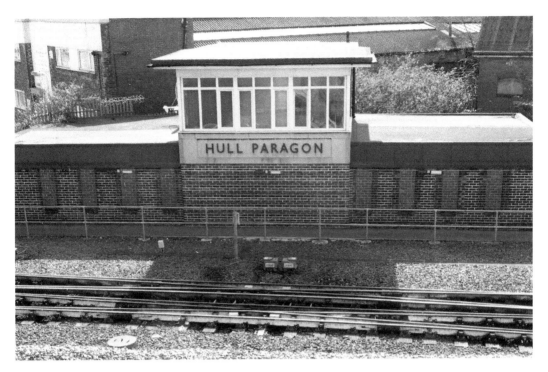

Fig. 37. The later art deco style of Hull Paragon signal box is reminiscent of some of the 1930s Southern Railway boxes, but without the rounded corners. (April 2015).

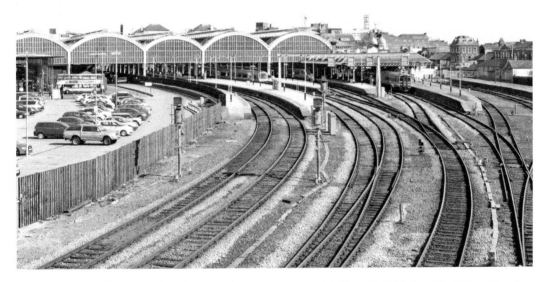

Fig. 38. Hull Paragon is a busy station once more with First Hull Trains, First TransPennine, Northern Rail, and Virgin East Coast operating services. (April 2015).

on one occasion. Much of the original station has survived Second World War bombing and some of it is listed.

Hull Paragon signal box is 18 chains (0.36 km) from the buffer stops at Hull Paragon station.

YORK – HARROGATE – LEEDS

The schematic not-to-scale diagram at Figure 39 shows a line not usually associated with the East Coast Main Line (ECML) and the high-speed drama that line has enjoyed. The line had originally been double-track and there was a junction at Starbeck, near Harrogate, to take the line north to Ripon and Northallerton, and to the ECML and Teeside. As traffic declined under BR, the Starbeck to Ripon line was closed and the line from Knaresborough to York partly singled.

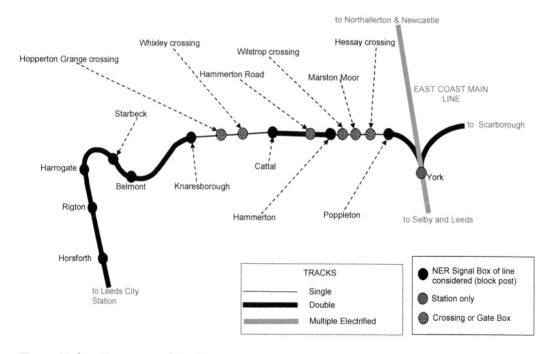

Fig. 39. York to Harrogate and Leeds.

Poppleton (P)

Date Built	NER Type or Builder	No. of Levers and/or Panel	Ways of Working	Current Status 2015	Listed Y/N
1870s	NER Type S5	11	TCB, KT	Active	N

Poppleton has nurseries that once provided food for NER restaurants and hotels.

The line operates Key Token from Poppleton to Hammerton, where the line reverts to double-track for a short distance. Key Token requires an instrument at either end of the single-line section, from which a token is withdrawn and presented to the train driver as authority to proceed. The train driver surrenders the token for that section and then collects a different token for the next section of single line, should it continue, or none if the line reverts to double-track. The action of removing a token from one end of the section locks the token instrument at the other end and prevents a token being issued in a conflicting direction. Points and signals are similarly locked. It is the train driver's responsibility to ensure the token received is appropriate for the section being travelled. Contiguous single-line sections are not a feature of this line and all sections are split up by AB-worked double-track or TCB at the Poppleton end.

Poppleton signal box is 2 miles and 74 chains (4.71 km) from York station.

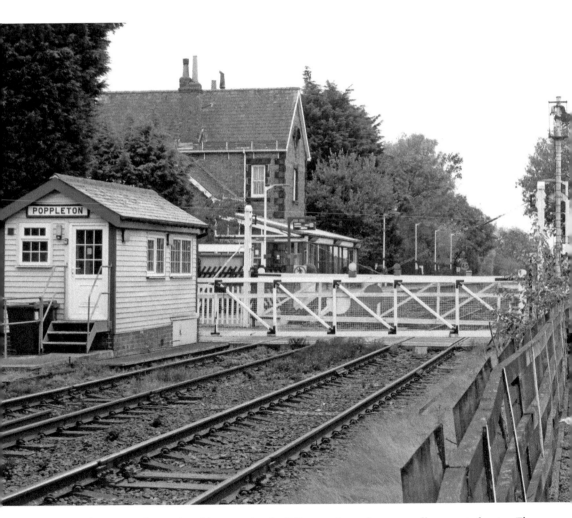

Fig. 40 shows Poppleton signal box, station building, and wooden manually operated gates. The line to York carries on after the gates and platforms. (October 2015).

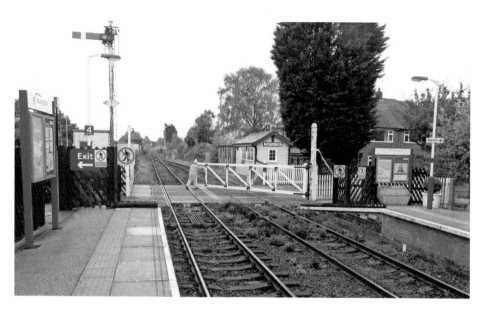

Fig. 41. The signaller closes the wooden gates to road traffic and the gates must be in the railway position and locked before any signals can be pulled off. The view is towards Marston Moor and Harrogate. (October 2015).

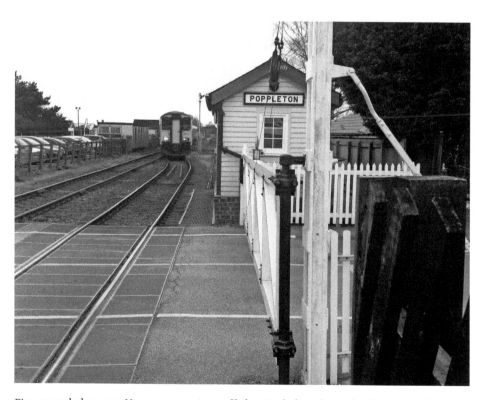

Fig. 42 and class 150 No. 150210 arrives off the single-line from the Harrogate direction towards the platform at Poppleton station, where the signaller collects the token from the train driver. (October 2015).

Hessay Crossing (H)

Date Built	NER Type or Builder	No. of Levers and/or Panel	Ways of Working	Current Status 2015	Listed Y/N
1848 (station)	Open Ground Frame	6	Gate	Active	N

Hessay crossing is 5 miles and 11 chains (8.27 km) from York station.

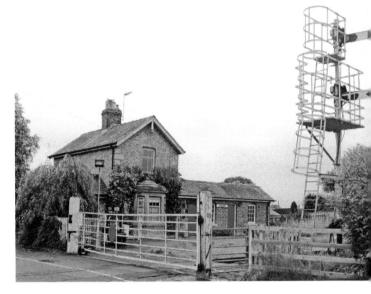

Fig. 43. Hessay crossing. This image was captured from the road, and the part of the station building in private hands is in the faintly National Trust colour scheme whereas the white window frames and blue doors are Network Rail's domain. The distant signal is Marston Moor's and is motor worked. Hessay's distant is further up the line towards York. (October 2015).

Fig. 44 is an earlier view of Hessay's former station building with ground frame outside. The two circular instruments in the case above the frame are distant signal status indicators as both of Hessay's distant signals are not visible from the ground frame. The single-storey addition to the building is the signaller's accommodation, housing the communications equipment. (October 2015).

Marston Moor (–)

Date Built	NER Type or Builder	No. of Levers and/or Panel	Ways of Working	Current Status 2015	Listed Y/N
1910	NE S5	16	Gate	Active	Y

Marston Moor is the site of the largest battle of the English Civil War, but is now the quintessential peaceful village. The signal box was listed in 2013 and the signaller interviewed by the BBC. The BBC were under the impression that the box was 165 years old, which would have made it the oldest on Network Rail should it have been built around 1848, when the station was built.

Marston Moor signal box is 6 miles and 6 chains (9.78 km) from York station.

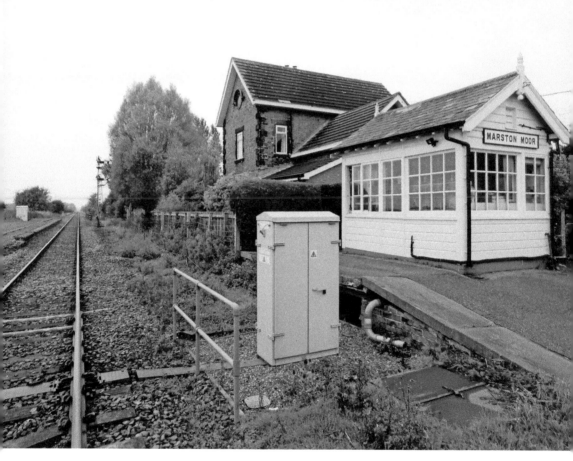

Fig. 45 and the box has been spruced up after its listing. The platform of the former station is clearly visible, as is the home and distant signal for trains coming from Harrogate. (October 2015).

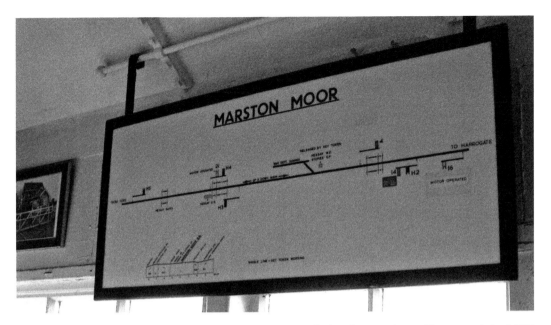

Fig. 46 shows that the diagram at Marston Moor includes the crossing at Hessay and the MOD siding, although the diagram refers to it as 'WAR DEPT', which puts the terminology in the 1960s or earlier. The box had been an Absolute Block post before the line between Poppleton and Hammerton was singled in 1972. (October 2005).

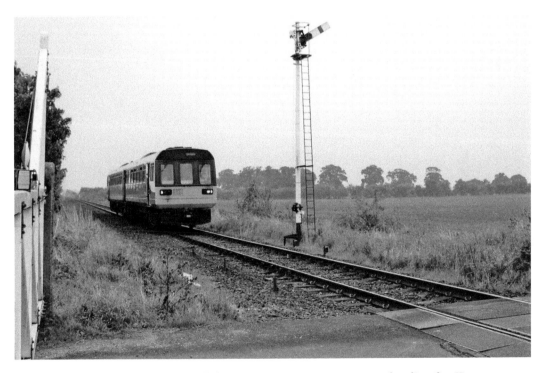

Fig. 47 is of an earlier view of class 142 Pacer DMU No. 142079 heading for Harrogate past Marston Moor's Down home signal. (October 2005).

Wilstrop Crossing (–)

Date Built	NER Type or Builder	No. of Levers and/or Panel	Ways of Working	Current Status 2015	Listed Y/N
1928	Ground Frame Westinghouse	5	Gate	Active	N

Wilstrop crossing is 7 miles and 45 chains (12.17 km) from York station.

Wilstrop crossing signaller's accommodation is shown in Fig. 48 and is unoccupied at the survey date. The lever frame at the other side of the road has all its levers pulled off and is consequently regarded as 'switched out'. The view is towards Harrogate. (October 2015).

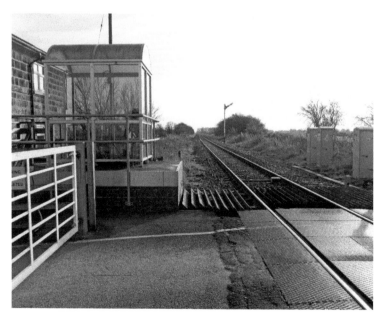

Fig. 49 shows a cut-down bus shelter-type structure containing the lever frame. The grey item on the track inside the right-hand rail provides an interlock that prevents a gate lock from being unlocked while a train is passing. (October 2015).

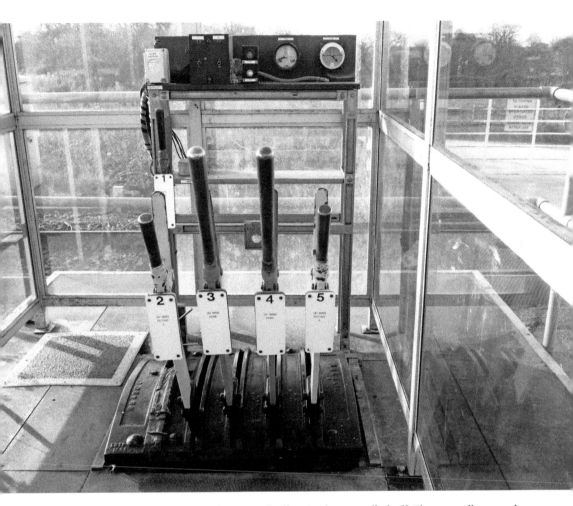

Fig. 50 is the ground frame at Wilstrop with all active levers pulled off. The two yellow cut-down distant signal levers control colour light signals and both red homes are semaphores as we can see from the previous figures. Lever 1 is the gate lock and that has been blanked off and both gates are manually opened and closed and padlocked into position by the signaller.

The circular instrument in the centre of the small panel is the single-line token apparatus status indicator and that is telling us that the Down line towards Harrogate is active at the moment. If neither direction is active it is described as 'Line Blocked'. The yellow circular instrument on the right is the Up distant signal, which is off, and the rectangular instrument showing green is the Down distant position status indicator for the Harrogate direction, also off. The frame is a Westinghouse Brake & Signal Co. product and moulded into the frame is the legend 'LNER 1928'. (October 2015).

Hammerton (H)

Date Built	NER Type or Builder	No. of Levers and/or Panel	Ways of Working	Current Status 2015	Listed Y/N
1972	Platform Cupboard	16 (frame dates – 1914)	KT, AB	Active	Y

Hammerton is another delightful village in the series along the line and, in common with Hessay station, the lever frame was out on the platform in the open until 1972. The Key Token instrument and AB instrument are inside the station building together with the computers and other communications equipment.

Hammerton station and signal box is 8 miles and 61 chains (14.1 km) from York station.

After Hammerton station is Hammerton Road Crossing, but as the building is only a portakabin and there is no signalling there, it has been omitted.

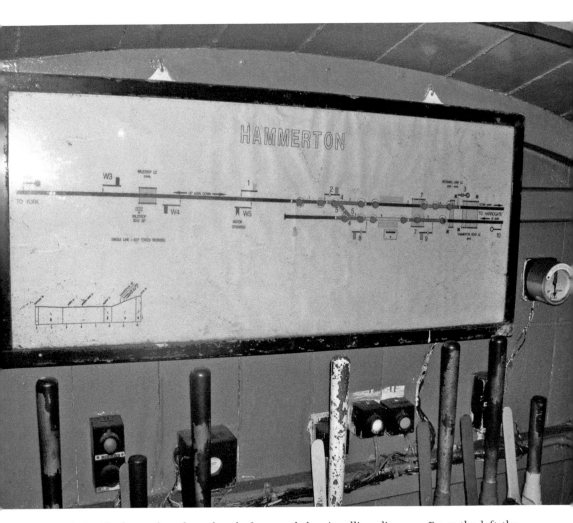

Fig. 51 is inside the cupboard on the platform and the signalling diagram. From the left the signals are: Wilstrop Crossing's then Hammerton's distant at lever 1; home (track circuited), lever 2; and the final signal towards Harrogate is lever 3, a colour light home signal.

From Harrogate towards York, from right to left, there is lever 10, a colour light distant, followed by 9 and 8, which are semaphore home signals. The two crossings, in the same order, are Hammerton Road and Hammerton station.

The circular instrument on the far right is a train approaching indicator, but this is here because the signaller cannot see the block instruments directly as they are in the station building. (December 2005).

Fig. 52 is the blue platform cupboard and station building. The track to the right is heading towards the single line and York. The crossover at the end on the platform by the home signal ends in a headshunt on the platform face side. (October 2015).

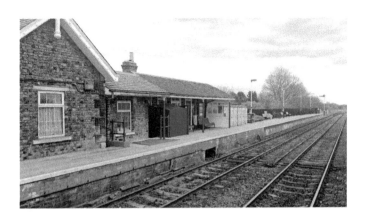

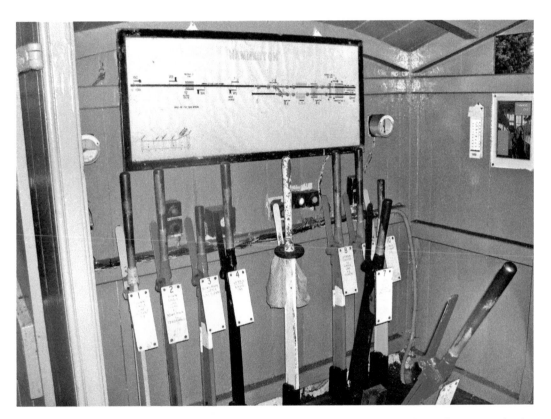

Fig. 53 is again inside the cupboard and of the lever frame. The circular indicator on the far left is lever 1's position status and the blue facing point lock lever is reversed, meaning the lock is withdrawn so the crossover can be changed over at will if required. It will need the lever replacing to normal to restore the locking to pull off signals. Levers 3 and 10 are both colour lights and so cut-down in size and red lever 3 is additionally electrically locked, by the white stripe, to mean that Cattal must select 'Line Clear' before it will pull off – a Welwyn Control. The spare white lever with the collar may have been a goods siding at some point. Note that the brown gate lock lever has a grey box at the bottom and this is an electrical switch. The gates must therefore be locked mechanically and electrically. There is a distant signal adjuster wheel here and the lever frame is moulded in relief, 'W B & S Co. Ltd' for Westinghouse Brake & Signal Company Limited. (December 2005).

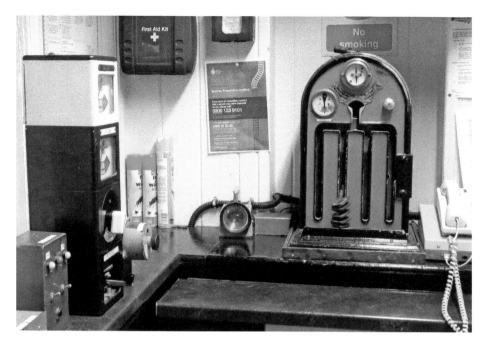

Fig. 54 is now out of the cold and into the station building. On the left the BR domino block instrument has 'Train on Line' selected and reflected, and the red Tyer's single-line token apparatus also has 'Train Coming From' on its small circular display on the top left of the instrument. Two trains are on the double-track and one on the single. The Tyer's instrument will be examined in detail at Cattal, the next block post. (October 2015).

Fig. 55 and some of that which is reflected on the instruments is unfolding outside. The Northern Rail Pacer DMU class 142 No. 142022 arrives off the single-line from York to a stand at the platform. The destination caption reads Leeds. The signaller has to nip over smartly to the platform to retrieve the single-line token, while the expected arrival from Harrogate is halted just outside the station at the home signal. (October 2015).

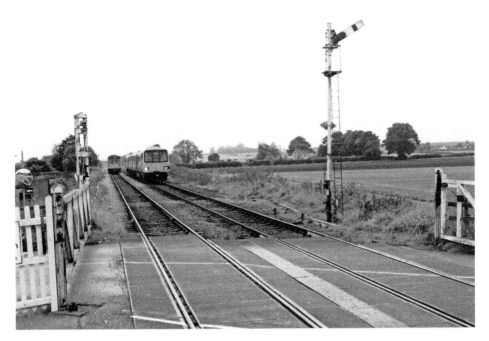

Fig. 56 is the Pacer No. 142022 accelerating towards Harrogate, and in the time it takes for the set to do this, the signaller has sped back to the cupboard and pulled lever 9 for the York-bound Pacer class 144 No. 144079 to enter the platform. As the signaller has to cross the tracks to do this, in the face of the oncoming class 144, the signal cannot be pulled off in advance. (October 2015).

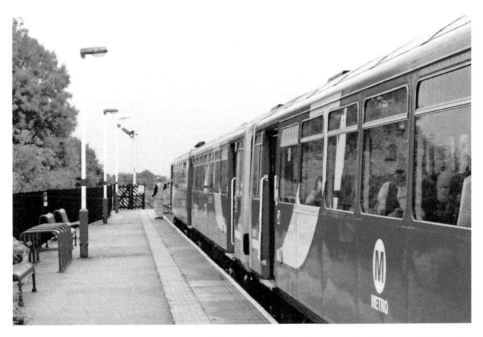

Fig. 57 sees the signaller come out of the cupboard to issue to the class 144 driver the single-line token to Poppleton. (October 2015).

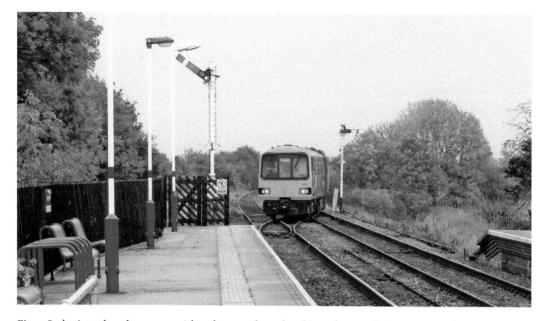

Fig. 58 depicts the class 144, with token on board, taking the single-line to Poppleton and eventually York. The signal that is off is lever 8 and the home that is on is lever 2, from the diagram at Fig. 51. (October 2015).

Cattal (C)

Date Built	NER Type or Builder	No. of Levers and/or Panel	Ways of Working	Current Status 2015	Listed Y/N
circa 1892	NE S5	15	AB, KT	Active	Y

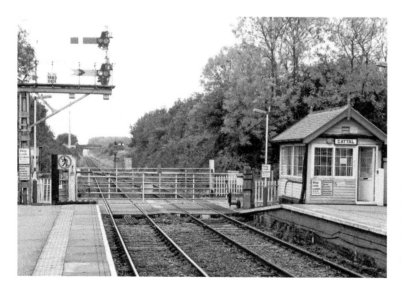

Fig. 59. Cattal signal box. A box in the style of Marston Moor, and all of the box's operable semaphore signals. (October 2015).

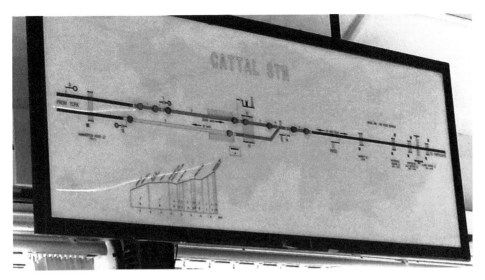

Fig. 60 displays a similar track layout to Hammerton, except that there is no crossover or headshunt here, just a single point where the line goes from double to single-line. The only other semaphore signal in addition to the ones we saw at Fig. 59 is a distant signal fixed at caution on the single-line approaching the junction. A train approaching from Knaresborough on the single-line will need to take the curved point selection, which would normally be taken at reduced speed, to be on the left-hand track for the double-line section, and therefore it makes sense to permanently caution trains at that place. There are a total of seven crossings on the diagram. (October 2015).

Fig. 61 is a view below the diagram of the block shelf and prominent there is the BR domino block instrument for the section to Hammerton. To its right is a block bell that is the single-line communication from Knaresborough. This is used with the Tyer's token apparatus, which is on a desk on the opposite wall. The set of flags for emergency use are on the left and the hotplate rings and microwave are in addition to the usual 1960s retro Baby Belling cooker. (October 2015).

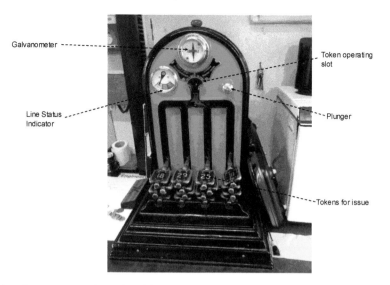

Galvanometer

Token operating slot

Line Status Indicator

Plunger

Tokens for issue

Fig. 62 is the aforementioned Tyer's tablet machine. These machines have been in operation for over a hundred years.

The machine is a receptacle for tokens not in use, as well as a socket or slot into which a token is placed to activate single-line working functions. The circular instrument at the top centre of the device is a galvanometer, which just senses a pulse of DC voltage and this is caused by the operation of the plunger switch at the other end of the line. The other instrument on the left is the equivalent of the AB train/line indicator except that here the white or blank selection is 'Line Normal' or clear, red is 'Train Coming From', and green is 'Train Going To'.

The plunger on the right is a plunger switch-type device that rings the block bell at Knaresborough, similar to the one on the block shelf here, and operates certain functions on the Tyer's machine.

As a means of describing how this gadget works, we will suppose a train is travelling the single-line from Cattal to Knaresborough and will use the abbreviations of each capital letter of the place:

1. C calls attention on the plunger, 1 beat and upon reply gives 3 beats pause 1 beat for an ordinary class 2 passenger train.
2. K replies one beat and then 3 pause 1. K holds in that plunger until the galvanometer needle flicks twice and that indicates that a token has been removed from C's machine. K releases the plunger.
3. C then places the removed token in the slot and gives it 2½ turns to the left which sets 'Train Going To' on the indicator. The Key Token can then be removed in preparation for handing to the train driver.
4. C then operates the plunger again, which changes K's machine to read 'Train Coming From'. K can now clear the signals for the approaching train, hitherto they have been locked.
5. C can now clear the signals in the path of the departing train and hand the train driver the already removed token.
6. When the train arrives at K the signaller there must check the tail lamp to ensure that the train has not divided in section and then replace the previously selected signals. K then places the token in that instrument and gives it 2½ turns to the right. K then plunges to C and this changes C's instrument to 'Line Normal' or clear and then gives C 2 pause 1 beats on the bell as 'Train Out of Section'.
7. C replies with 2 pause 1 to acknowledge and C then plunges which turns K's instrument to 'Line Normal' or clear.

Another train in either direction can now be sent. There are arrangements in place to reset the system should the need arise to cancel a movement. (October 2015).

Cattal is in some ways complementary to Hammerton in that they are both the end and start of a double-track section and the end and start of a single-track section. The double-track between Hammerton and Cattal is effectively a long loop at just over 2 miles (3.2 km) long. The line then reverts to single-track to Knaresborough, from whence it is double-track to Harrogate.

Cattal signal box is 10 miles and 20 chains (16.5 km) from York station.

Whixley Crossing (–)

Date Built	NER Type or Builder	No. of Levers and/or Panel	Ways of Working	Current Status 2015	Listed Y/N
Not Known	Portakabin	5 (estimated)	Gate	Active	N

Although this is a crossing it is perhaps unusual to start off the piece with the crossing gates.

Whixley crossing is 11 miles and 8 chains (17.86 km) from York station.

Fig. 63. These gates, or rather the red 'targets' on them, are unique now on Network Rail in acting as the semaphore red home signals for the crossing. The signal is on if the crossing is closed against the railway and off if closed against the road. Note that the far gate is a modern replacement as the original was apparently taken out by a motorist. (October 2015).

Fig. 64 sees only a distant signal outside the crossing as the gates are themselves the home signals as previously described. Note the NER C. N. Wilkinson cast sign and modern wicket gate with no lock. (October 2015).

Knaresborough (K)

Date Built	NER Type or Builder	No. of Levers and/or Panel	Ways of Working	Current Status 2015	Listed Y/N
circa 1873	NER Non Standard	12	KT, AB	Active	Y

The signal box is a complete 'one off', built to fit in on the end of a terrace of Georgian stone-built houses, but in the Victorian style of the viaduct it is next to.

Knaresborough signal box is 16 miles and 54 chains (26.84 km) from York station.

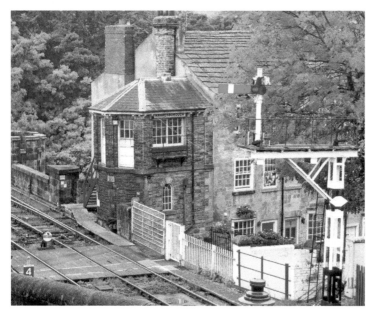

Fig. 65. Knaresborough signal box. The view is from Hilton Lane, towards Harrogate. The line has reverted to double-track just before the 176-yard (164 metres) Knaresborough tunnel and directly after the tunnel is the station. (October 2015).

Fig. 66 depicts Northern Rail class 153 single-car unit No. 153360 ready and has the off for Leeds after Harrogate. Note the original station buildings and the close proximity of Knaresborough tunnel portal at the end of the platform. There is a steam-age water tower base on the other end of the near platform. (October 2015).

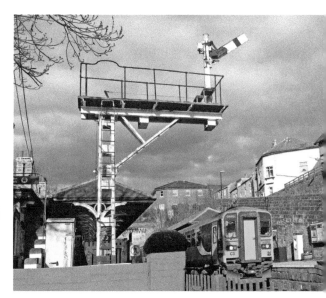

Fig. 67 is the route to Harrogate over the viaduct. The trailing crossover looks well used and this is clearly the point at which trains that have arrived from Harrogate can reverse to return in that direction. The crossover point nearest the camera is equipped with a facing point lock and we can see the rod that operates the lock at the bottom of the picture heading for the point tie bar. The tie bar has two slots cut into it and the squared end of the rod engages in one of the two slots, depending on the point's position. There is also a grey 'detector' box on the left that locally interlocks the ground signal with the point position. (October 2015).

Belmont (–)

Date Built	NER Type or Builder	No. of Levers and/or Panel	Ways of Working	Current Status 2015	Listed Y/N
1914	NER Type S5	5	Gate	Active	N

On the outskirts of Harrogate now is Belmont near Starbeck.

Belmont signal box is 17 miles and 69 chains (28.75 km) from York station.

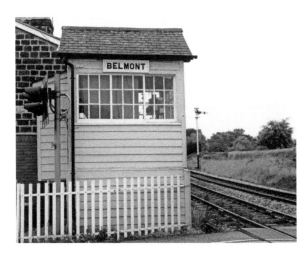

Left: Fig. 68. Belmont is a gate box like no other, and about as small as a working signal box can be. This is the view towards Harrogate.

The five levers would seem to be two each for Up and Down line signals, and one gate lock. There are no points here. (October 2015).

Below: Fig. 69 is the view towards Knaresborough at an earlier date. The signal is now no longer there. (December 2005).

Starbeck (SB)

Date Built	NER Type or Builder	No. of Levers and/or Panel	Ways of Working	Current Status 2015	Listed Y/N
1915	NER Type S1a	26	AB	Active	N

Starbeck had been the junction when the Ripon line to the ECML was open.

There had been several boxes hereabouts and Starbeck had been Starbeck South with 51 levers and a gate wheel.

Starbeck signal box is 18 miles and 24 chains (29.45 km) from York station.

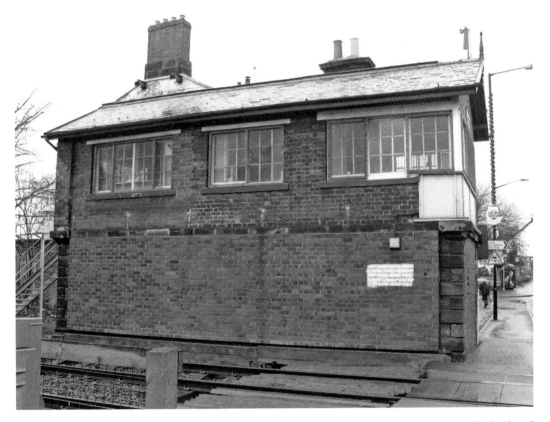

Fig. 70. The box saw a reduction in traffic from 1969 when the Ripon line was completely closed but still looks imposing enough, despite the completely bricked-up lower floor. (December 2005).

Harrogate (H)

Date Built	NER Type or Builder	No. of Levers and/or Panel	Ways of Working	Current Status 2015	Listed Y/N
1947	LNER Type 15+	45	AB	Active	N

Harrogate is a famous spa town that saw popularity soar with the railway's arrival.

Harrogate signal box is 20 miles and 30 chains (32.79 km) from York station and 17 miles 24 chains (27.84 km) from Wortley Junction in Leeds. From now on mileages are calculated from the latter destination and Up is now towards Leeds.

Fig. 71 shows a modernistic, faintly Festival of Britain-style signal box with reduced facilities. It had been 65 levers and had been named Harrogate North – a name it retained at the survey date. Knaresborough and York are to the left. (December 2005).

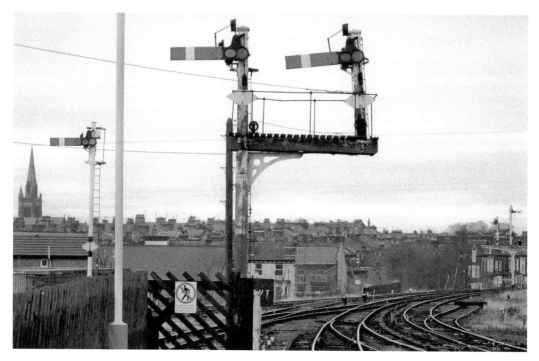

Fig. 72 shows an LNER bracket signal as the starter for Platform 1 and the through avoiding line. The angle cranked rods coming out from the signal arms are connections to electrical position transmitters. The signal gantry is North Eastern Railway and is a remarkable survivor. The starter signal on the left is for bay platform number 2. Note the short siding with the sleeper as a buffer stop and the yellow striped ground signal. The view is towards Knaresborough. (December 2005).

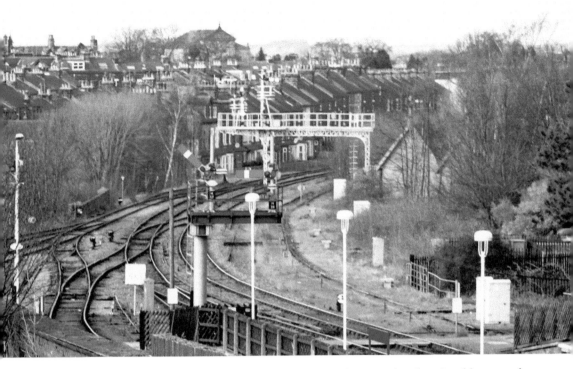

Fig. 73 is a view ten years on from the previous figure. The LNER bracket signal has gone but has been replaced by semaphores, and the gantry has had the Health and Safety treatment with additional ladders and hoops. The third signal is on the same 'doll' or post as the larger semaphore. The short siding has gone.

The yellow striped ground disc has moved to a black and yellow scheme. The Down line inner home can just be seen beyond the gantry. In this context, Up is towards York. (March 2015).

Rigton (RN)

Date Built	NER Type or Builder	No. of Levers and/or Panel	Ways of Working	Current Status 2015	Listed Y/N
circa 1873	NER Type S1a	6	AB	Demolished 2013	N

Rigton was one of the earliest NER signal boxes and had been considered for listing by Historic England. It contained only 6 levers but had two BR domino AB instruments to pass trains back and forth and originally had a gate wheel for the crossing.

Rigton signal box was 12 miles 15 chains (19.61 km) from Wortley Junction in Leeds.

The line passes through Bramhope Tunnel, which is 2 miles 241 yards (3.44 km) long, on its way to Leeds.

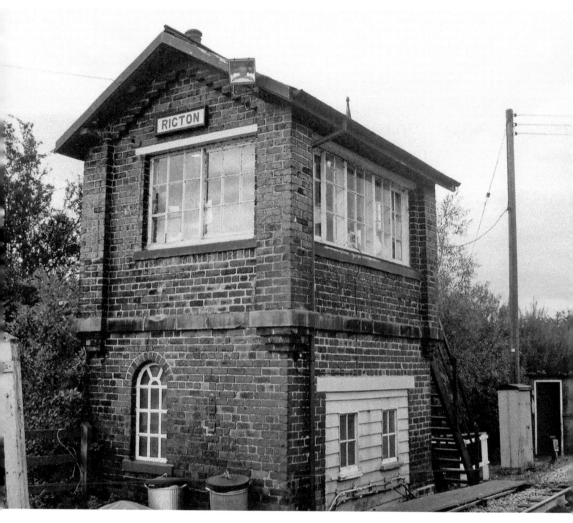

Fig. 74. Rigton signal box. The box looks substantially original. There had been a trailing crossover to the right of the box and that had been clipped and spiked out of use for some years. In later years this was and is an all-colour-light signal area. (October 2006).

Horsforth (H)

Date Built	NER Type or Builder	No. of Levers and/or Panel	Ways of Working	Current Status 2015	Listed Y/N
1873	NER Type S1b	15	AB	Demolished 2013	N

Horsforth was also one of the earliest NER signal boxes, but as there was a goods yard here, there were more levers than at Rigton.

Horsforth signal box was 4 miles 70 chains (7.85 km) from Wortley Junction in Leeds.

Fig. 75. Horsforth signal box. Horsforth signal box looks well looked after, with even some gardening going on. There is another yellow-striped ground disc on display and it controls the exit from the goods yard onto the Down running line towards Harrogate. A train may pass the disc at caution when using the headshunt, but not for the route signalled. The original goods shed survives but in non-railway use. (October 2006).

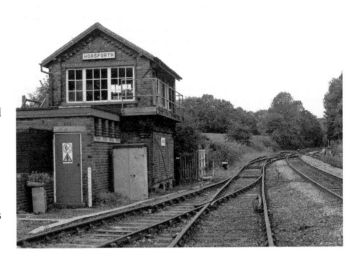

YORK – SCARBOROUGH – HULL

The schematic not-to-scale diagram at Figure 76 displays a journey mostly west to east with a meander south down the east coast to Bridlington and Hull. The railway makes its way through pleasant scenery, mostly between the North Yorkshire Moors and the less hilly Yorkshire Wolds, after which it heads south following the coast and skirting the Wolds before turning inland.

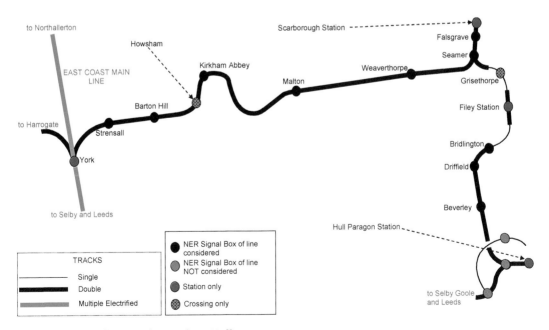

Fig. 76. York to Scarborough to Hull.

Strensall (S)

Date Built	NER Type or Builder	No. of Levers and/or Panel	Ways of Working	Current Status 2015	Listed Y/N
1901	NER Type S2	IFS Panel	TCB, AB	Active	N

Strensall has been associated with the army since Victorian times but is also a commuter village for York. No doubt commuters would have found the station handy for the journey to the city, but it closed in 1930.

Strensall signal box is 6 miles 48 chains (10.62 km) from York station.

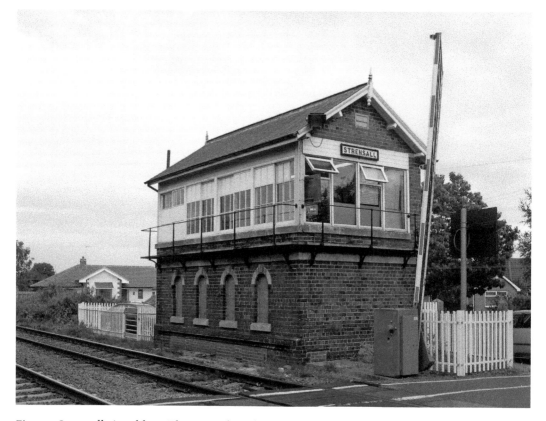

Fig. 77. Strensall signal box. There are three level crossings in Strensall – one with manual gates – although the box here is a block post. (September 2006).

Barton Hill (BH)

Date Built	NER Type or Builder	No. of Levers and/or Panel	Ways of Working	Current Status 2015	Listed Y/N
1936	LNER Type 13	16	AB	Active	N

Barton Hill signal box is a modern interloper on a line where equipment tends to be somewhat older, but in this case the LNER provided this replacement box as part of local authority works to improve the road at the crossing. The crossing is unusual in that it has gate-wheel-operated barriers in November 2015. The station here was also a casualty of the 1930s closures as the depression began to bite.

Barton Hill signal box is 11 miles 48 chains (18.67 km) from York station.

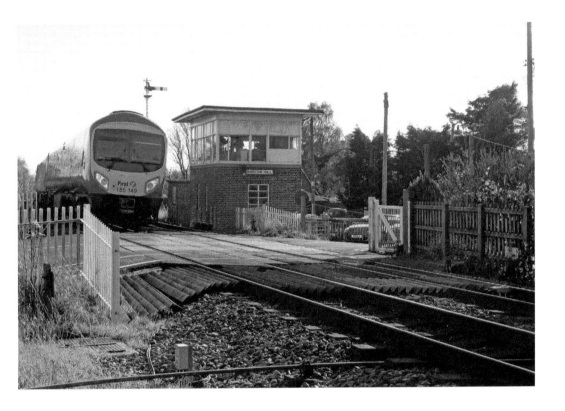

Above: Fig. 78 and Barton Hill still looks spruce and modern. First TransPennine class 185 No. 185149 accelerates towards Scarborough after a signal check at the crossing. The rod in the foreground is part of the gate wheel mechanism to move the barrier that is out of shot to the left. (November 2015).

Right: Fig. 79 gives the general public a dire warning as to trespass. Note that the cast-iron sign is finished in BR North Eastern Region tangerine. (August 2004).

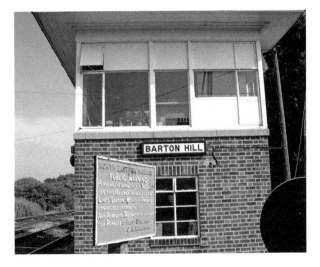

Howsham (–)

Date Built	NER Type or Builder	No. of Levers and/or Panel	Ways of Working	Current Status 2015	Listed Y/N
circa 1873	NER Type S1b	8	Gate	Active	N

Howsham is not far from the York to Scarborough main road and yet seems to be in a timewarp world of its own. The box was crewed by a husband and wife team, Val and George.

Howsham signal box is 13 miles 28 chains (21.48 km) from York station.

Fig. 80. Howsham signal box. The sleeper-built shed with the horseshoe over the doorway was in use as a kindling firewood store at the survey date. (August 2004).

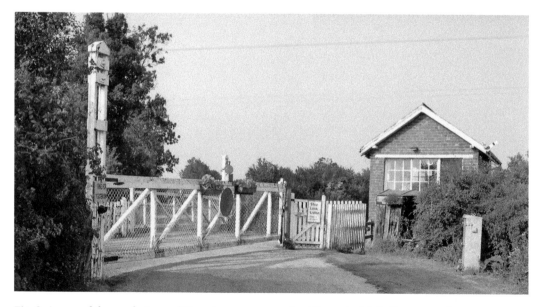

Fig. 81 is one of the road views of Howsham as approached from the York direction. The sign on the left says 'RING FOR GATEMAN', although Val and George used to maintain the grass verges here and live in the former NER station building just by the crossing before their retirement. One of them is in attendance as a train is expected from Scarborough. (August 2004).

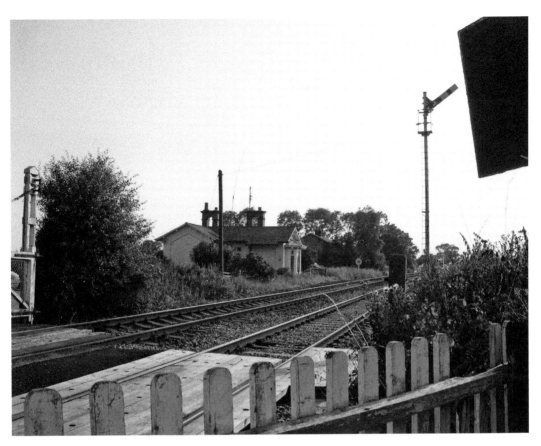

Fig. 82 shows us the signaller's residence, the former station building. It opened in 1848 and closed soon afterwards. A train is due from York. The cast-iron sign in shot at the top left is another of the C. N. Wilkinson NER trespasser signs. Note the guy post and wires supporting the signal post. (August 2004).

Fig. 83 displays the inside of Howsham box with the lever frame and block shelf equipment. The charming homemade painted board behind the levers explains what they do very well. The gates are unlocked.

There is a block bell, whose wooden case is just visible on the block shelf, and that rings every time the signaller at Barton Hill or Kirkham Abbey operates their block bell. The signaller at Howsham refers to the Trust WTT computer to understand who is calling. (2015).

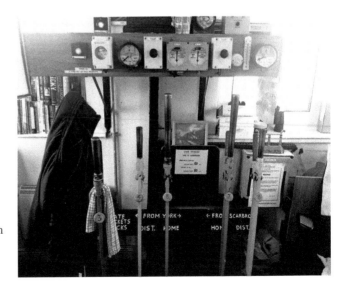

Kirkham Abbey (K)

Date Built	NER Type or Builder	No. of Levers and/or Panel	Ways of Working	Current Status 2015	Listed Y/N
circa 1873	NER Type S1a	16	AB	Active	Y

Kirkham Priory nearby is Grade I listed and attracts many visitors who find a picnic by the River Derwent appealing.

Kirkham Abbey signal box is 15 miles and 1 chain (24.14 km) from York station.

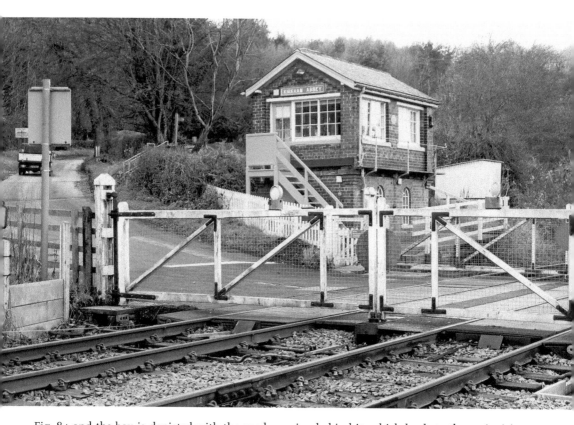

Fig. 84 and the box is depicted with the road running behind it, which leads to the main A64 road. The box has a gate wheel to operate the crossing gates at this date and some of the rodding can be seen emerging from the nearer side of the crossing. The grey rod between the double-tracks is the gate lock. Note the NER period cast-iron distance sign, which pronounces 'YORK 15'. Not only has the box been awarded a blue plaque but is also finished in British Railways North Eastern Region 1950s livery. (December 2015).

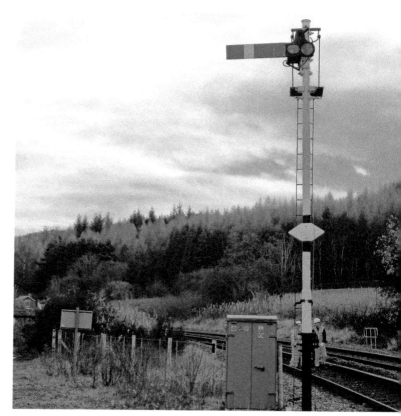

Fig. 85 is the Up home signal looking towards York with the box in the distance to the left. The track workers are wielding a 'fishplate spanner', used to tighten up track joints in non-welded rail areas. They were dismantling fishplates and greasing the assembly at the survey date. (December 2015).

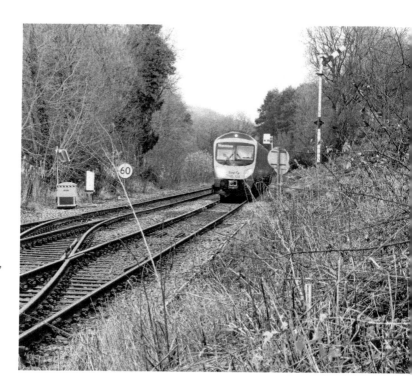

Fig. 86 is the view towards York and First TransPennine class 185 No. 185128 is hurtling down towards Scarborough, with the Up home signal above the DMU placed on the opposite side of the tracks to the usual for sighting reasons. (December 2015).

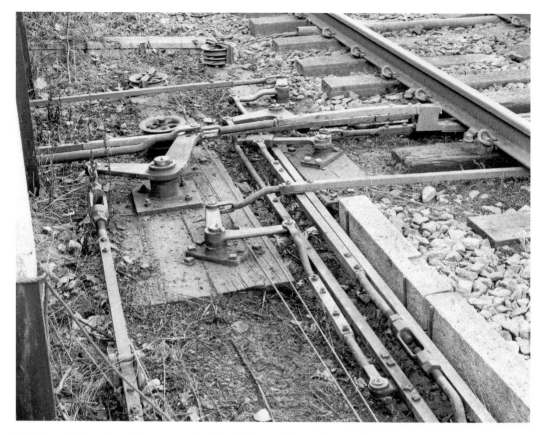

Kirkham Abbey signal box gate and point linkages. (December 2015).

Fig. 87 is a close-up view of the rodding and signal wires emerging from Kirkham Abbey signal box.

The massive angled crank in the middle is the gate mechanism itself, the smaller set nearest the camera are the gate locks, and the uppermost crank, furthest from the camera, is the trailing crossover that is the other side of the crossing we glimpsed in Fig. 86.

Malton (M)

Date Built	NER Type or Builder	No. of Levers and/or Panel	Ways of Working	Current Status 2015	Listed Y/N
circa 1873	NER Type S1a	IFS Panel	TCB, AB	Active	N

Malton had been a considerable junction in steam days, with the most notable branch to Whitby through Pickering. The remnants of this branch form the North Yorkshire Moors Railway (NYMR).

Malton signal box is 21 miles and 32 chains (34.44 km) from York station.

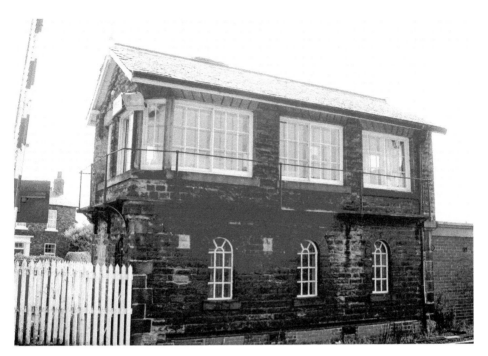

Fig. 88. Malton signal box was formerly Malton East and is about a quarter mile (400 metres) from the station. It supervises the crossings further east towards Weaverthorpe and the area where the former junction with the NYMR was at Rillington. (August 2004).

Fig. 89 shows Malton station cut back to one platform with the double-track main line alignment spaced out. Beyond the main line are a couple of sidings. Trains that need to stop at Malton have to use facing and trailing crossovers to access the platform and then regain their running line if necessary. (August 2004).

Weaverthorpe (W)

Date Built	NER Type or Builder	No. of Levers and/or Panel	Ways of Working	Current Status 2015	Listed Y/N
circa 1873	NER Type S1a	16	AB	Active	Y

Weaverthorpe signal box has a companion in style with Norton South, which is in *Signalling & Signal Boxes Along the NER Routes Volume 2*.

Weaverthorpe signal box is 32 miles and 68 chains (52.87 km) from York station.

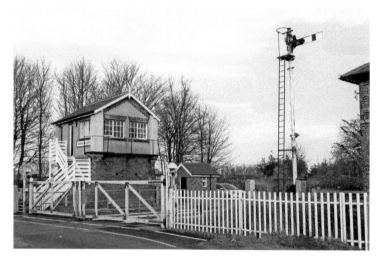

Fig. 90. Weaverthorpe signal box is quite odd in that the box presents what would normally be an end as a side. In any case, it is quirky enough to be a listed building. (December 2015).

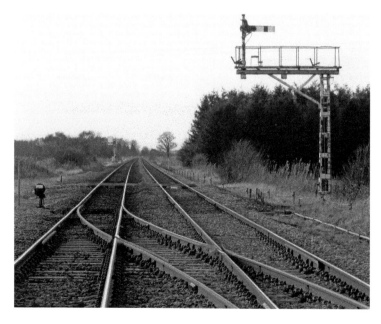

Fig. 91 is the line back towards Malton with trailing crossover and ground signal for a reversing move over it. The other ground disc is the far side of the road crossing. (December 2015).

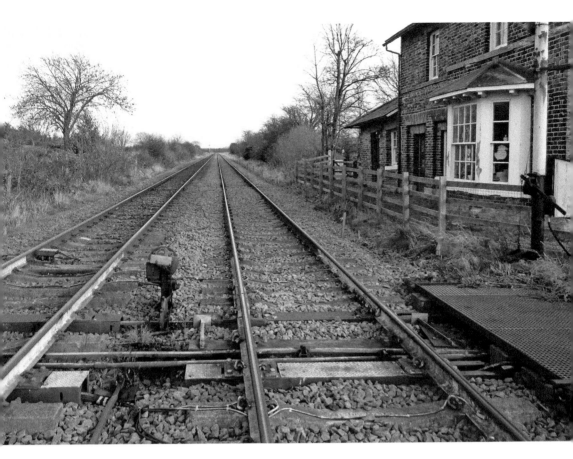

Fig. 92 is the Down line towards Scarborough and the trailing crossover ground disc is this side of the crossing, whereas the crossover is the other side. The Down home signal is almost on the horizon, and the NER elevated coal drops were behind the box in the goods yard. Part of the supporting piers survives on the left. The gate mechanism rodding is in the foreground. Note how hollow steel channel sleepers are used to conduct the rodding.

The passenger station platforms were this side of the crossing as well as the station building shown, which doubled as a residence. (December 2015).

Seamer (SR)

Date Built	NER Type or Builder	No. of Levers and/or Panel	Ways of Working	Current Status 2015	Listed Y/N
1910	NER Type S4+	NX Panel	AB, TCB	Active	N

Seamer is the next stop before Scarborough and holidaymakers would associate its arrival as progress towards the seaside.

Seamer signal box is 39 miles and 17 chains (63.12 km) from York station.

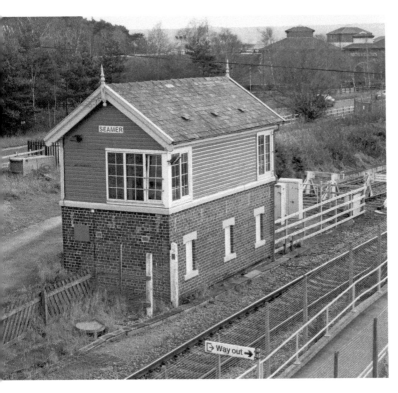

Fig. 93. Seamer signal box, formerly Seamer East, has been extensively modernised and now controls the lines into Scarborough and the station itself now that Falsgrave signal box has closed (as of November 2015). It also works single-line Track Circuit Block to Bridlington through Filey, although there is a short double-line section from Hunmanby to Filey. (December 2015).

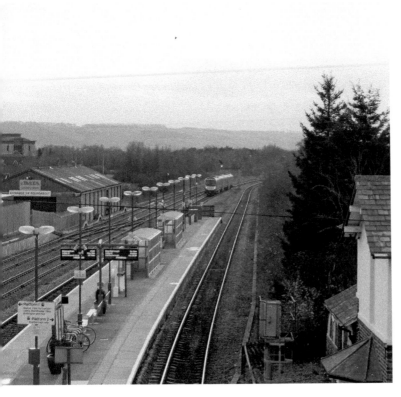

Fig. 94 is an overview of the island platform and First TransPennine class 185 powers towards York past the junction signal for the line to Bridlington and Hull. There are two sidings here with a run-round crossover in current use. (December 2015).

Falsgrave (F)

Date Built	NER Type or Builder	No. of Levers and/or Panel	Ways of Working	Current Status 2015	Listed Y/N
1908	NER Type S4	120	AB	Closed	Y

Like so many other resorts, Scarborough was popularised by the railway for the masses, as until the eighteenth century the town had been the preserve of the wealthy.

Falsgrave is a district in Scarborough and the signal box was an outpost at the station, so to speak, until the excursionist facilities came out to meet it. In 1908, the NER was having difficulty in coping with the mass numbers of passengers and so built a station beyond Falsgrave at Londesborough Road. It consisted of only two platforms. The station was closed after the August holidays in 1963 but some of it survives – as a bus depot.

Falsgrave signal box is 41 miles and 63 chains (67.25 km) from York station.

From Scarborough southwards towards Hull the mileages are calculated from the buffer stops at Hull Paragon station.

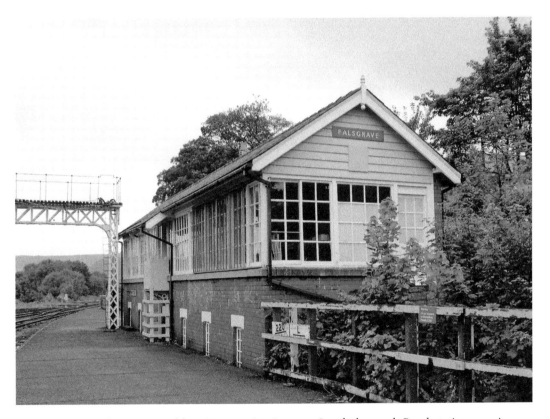

Fig. 95 is Falsgrave signal box in operation in 2004. Londesborough Road station remains are out past the box towards York. The box has been almost surrounded by a platform, as can be seen by the locking frame windows, and this is Platform 1, which is by far the longest. The NER signal gantry now on the North Yorkshire Moors Railway at Grosmont can just be seen. (August 2004).

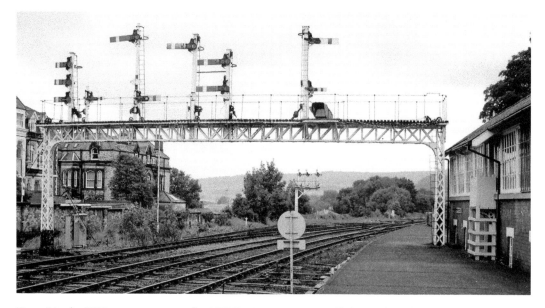

Fig. 96 is the NER gantry now on the NYMR. However, it is still doing the job here with LNER wooden posts mostly and only two tubular steel interlopers. Another concession to modern times is the route indicator on the right. A route indicator enables fewer signal posts and arms to be used.

The three signals on the post on the far left are referred to as 'stacked' and the meaning is that the upper one will refer to the far left carriage siding, and the bottom one the far right siding. The bracket signal with the three subsidiary arms on in the background are the three carriage siding exit signals. These sidings are referred to as the Up sidings – that is, towards York – and across the tracks are the arrival and departure platform tracks for the long-closed Londesborough Road station. There are three further sidings on the same side and this is where the turntable used to turn the steam locomotives that power the Scarborough Spa Express is located. This is a revival of the name of a dining car express that ran from the 1930s from Kings Cross and changed engines at York. (August 2004).

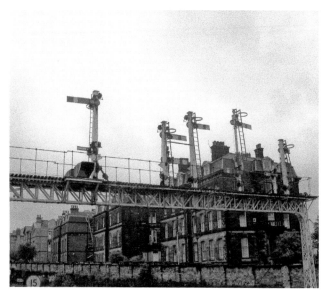

Fig. 97 is the other side of Falsgrave gantry looking towards the buffer stops at Scarborough station. The main arrival signal from the Down line has a calling-on arm, with the horizontal striping, for Platform 1. This is used to stop and caution a train that is about to enter a platform already occupied by a train, and Platform 1 could handle two trains. The taller tubular post also has a signal for the opposite direction, which was then a rare feature and would seem to signal a train from the Londesborough Road sidings into a platform. (August 2004).

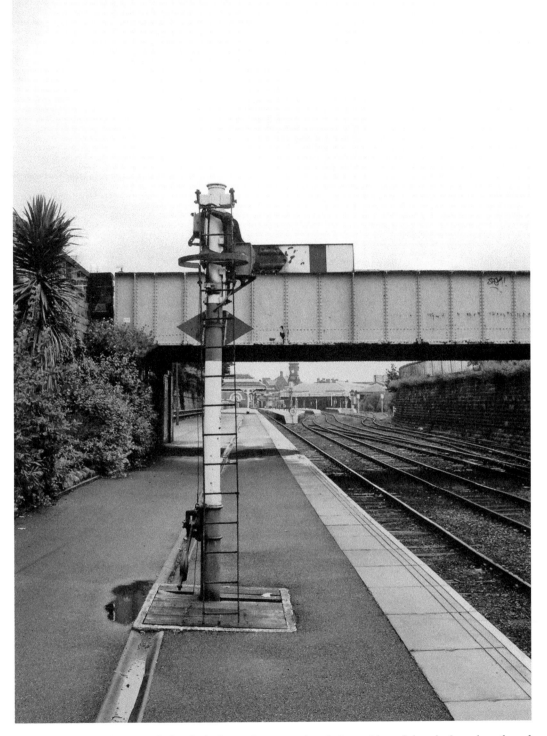

Fig. 98 is a shot from behind Platform 1's starter signal. Some idea of the platform length and its ability to accommodate two trains at once can be seen. Just under the bridge, on the left, is reputedly the longest platform seat in the world at 152 yards (139 m). (August 2004).

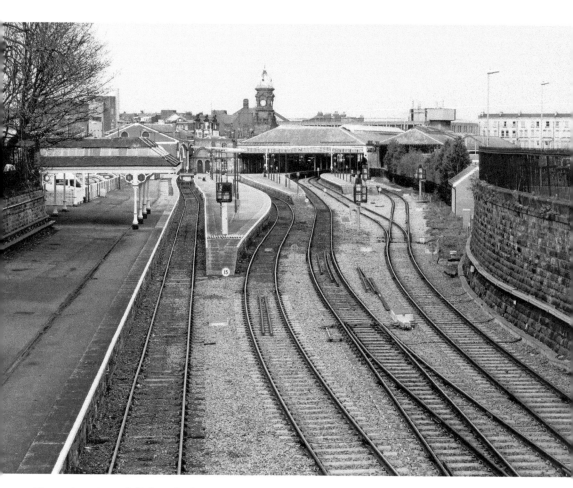

Fig. 99 is a view of all five platforms from Belgrave Terrace over bridge. The overall roof on the far right that was used to accommodate further rail-borne traffic is also visible. It had originally been a goods shed but was converted to accommodate platforms 6 to 9, which are now not in use. (December 2015).

Gristhorpe (G)

Date Built	NER Type or Builder	No. of Levers and/or Panel	Ways of Working	Current Status 2015	Listed Y/N
1874	NER Type S1b	15	Gate	Active	Y

Gristhorpe signal box was supposed to close in 2000 but the reason it has survived has remained partially obscure. The crossing would need to be widened to accommodate two lanes, and although it is thought a compulsory purchase was attempted, the local authority did not agree to it. The box sees about fourteen trains a day weekdays and six at weekends.

The single-line Track Circuit Block section expands to double-track for a short section between Filey and Hunmanby so a more frequent service can be accommodated.

Gristhorpe signal box is 46 miles and 39 chains (74.81 km) from Hull Paragon station.

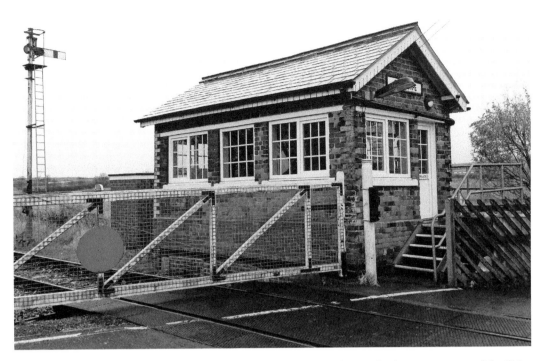

Fig. 100. Gristhorpe resembles Howsham as a small gate box in both appearance and facilities except that the line here has been singled. The gates here are manually operated and mechanically locked. (December 2015).

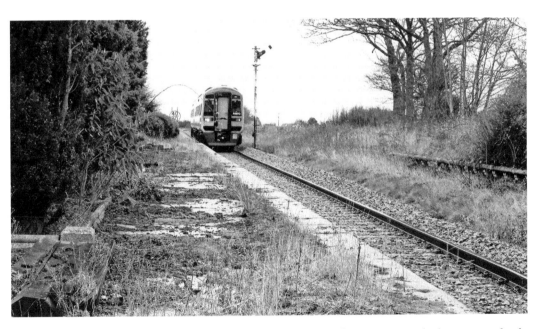

Fig. 101 is the view towards Filey, past the remains of Gristhorpe station. The layout was clearly double-track here at one time, as the remains of the far platform testifies. The LNER was into concrete in the 1930s and concrete garden edging can be seen on the left. Northern Railways class 158 No. 158872 drifts towards Bridlington. (December 2015).

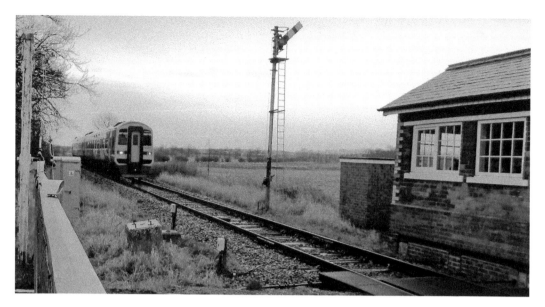

Fig. 102 was taken from the opposite crossing gate from the previous figure with Northern Rail class 158 No. 158921 tooting its horn as it rolls past the crossing on its journey towards Seamer and Scarborough. The rodding for the gate lock is clearly visible. Some preparatory work to convert the crossing to Automatic Half Barriers (AHB) has pre-emptively been done. (December 2015).

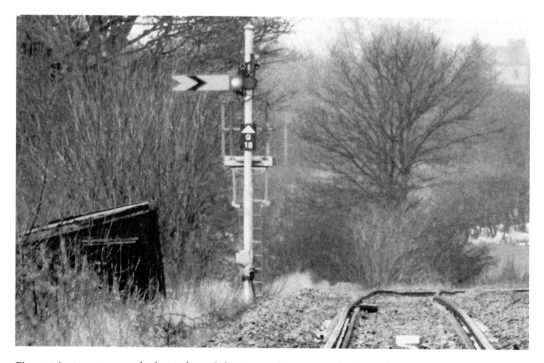

Fig. 103 is an extreme telephoto shot of the Down distant at Gristhorpe from Muston crossing towards Filey, which is about a mile (1.6 km) from Gristhorpe box. In common with many distant signals that are this far away from the box it is motor-worked, and the grey motor unit can be spotted near to the bottom of the post. (December 2015).

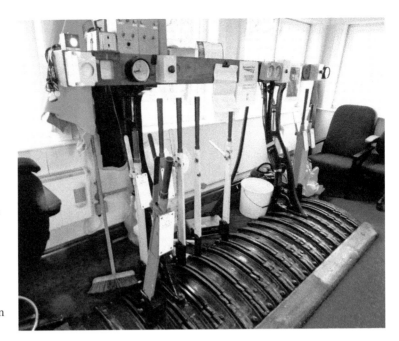

Fig. 104. Finally at Gristhorpe, there is a view inside the box. The gate lever is unlocked and the layout is reduced to home and distant signals for each direction. Both distant yellow levers are cut-down, indicating they are both motor-worked and the levers only operate switches. The two grey train indicator boxes are both controlled from Seamer. (2015).

Bridlington (BN)

Date Built	NER Type or Builder	No. of Levers and/or Panel	Ways of Working	Current Status 2015	Listed Y/N
circa 1893	NER Type S1a	65 and IFS Panel	TCB, AB	Active	N

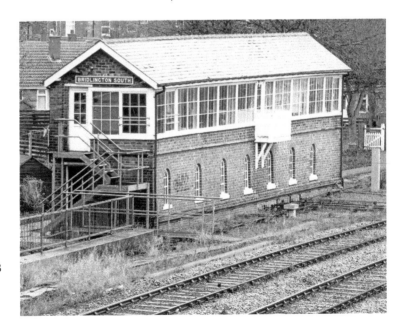

Fig. 105. Unlike Falsgrave, Bridlington signal box has been drastically cut back from 125 levers to the present 65 and some idea of the track layout may be gained when it is realised this was only the South signal box. The Individual Function Switch panel is for the TCB single-line to Filey and Scarborough. (December 2015).

Bridlington is a delightful Georgian seaside resort that has a fishing port and, originally, trade links with the export of grain and flour. Bridlington has been seen as Hull's resort, but on August Bank Holiday Monday in 1963 there were extra fifty trains to Bridlington from York, as well as Scarborough.

Bridlington signal box is 30 miles and 58 chains (49.45 km) from Hull Paragon station.

Fig. 106. The platform layout also suffered in a 1974 retrenchment and at the survey date the platform numbers went 4, 5, 6, 7, 8 and all five of the platform starters are on view. On the far right is an extraordinary survivor in the shape of a platform lamp on one of the former platforms, still with the legend 'Bridlington' on the lamp shade. (December 2015).

Fig. 107 shows a Northern Rail class 158 ready to depart from Platform 6 for Sheffield. Both the platform starter and section signal for the Up main line towards Hull are off. The illuminated caption, towards the top left, was a confirmation to the guard on the train of the signals' status as the guard was, in days past, in charge of the train and could not give 'right away' unless in possession of the clear nature of the route. (December 2015).

Fig. 108 is the camera turned through 180 degrees and the platforms read from left to right: 4, 5, 6, 7, 8. Note that the excursion platforms 7 and 8 have no working lamps on them and this is a sure sign that only summer working is ever contemplated. The commencement of the single-line and the TCB colour light signal is just visible between platforms 4 and 5. Platforms 7 and 8 used to have a GT Andrews overall roof. The double-tracked goods shed is by the red colour light signal. (August 2004).

Fig. 109 is shot from the B&Q car park just up from the station. There is a movement of the Down line with the arrival of the Northern Rail class 158 No. 158872 from Hull. The striped calling-on arm would only be needed if a train were to be signalled into a platform already occupied by another train, which would be quite likely with summer excursion traffic. Signals that require local interlocking because they are on the same signal post are termed as 'slotted'. (December 2015).

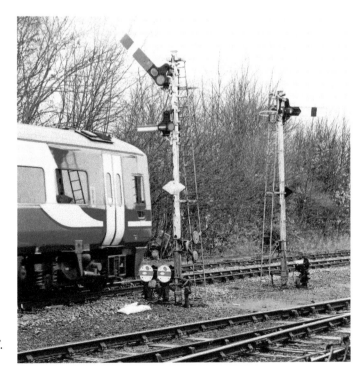

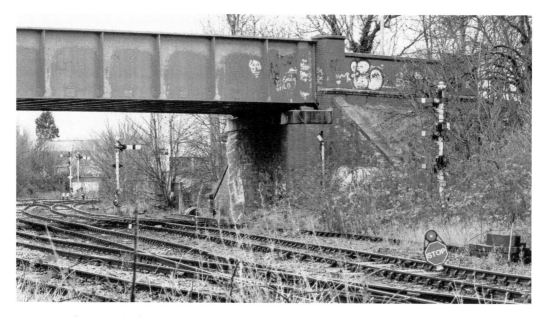

Fig. 110 is the view further out from the station, yet again at Hilderthorpe Road. The cluster of signals we saw at Fig. 106 is to the left beyond the bridge but the three signals on the same post, the camera side of the bridge, are referred to as 'stacked'. The bottom signal refers to a track on the extreme right, the next one up the centre, and the uppermost the left-hand track. These three signals give destinations for the one exit from the three carriage sidings; in other words there is only one exit signalled but it has three places to go. The sidings themselves are not signal box-controlled and we can see a manual point lever on the far right of the picture. (December 2015).

Fig. 111 is the last part of the journey towards Hull at Bridlington and Northern Rail class 158 No. 158901 accelerates up towards the outer home signal, past the three carriage sidings on the left with their stacked signal that we saw in Fig. 110. (December 2015).

Driffield (D)

Date Built	NER Type or Builder	No. of Levers and/or Panel	Ways of Working	Current Status 2015	Listed Y/N
1875	NER Type S1a	3 & IFS Panel	AB	Active	N

Driffield, or Great Driffield to give it its proper title, is a charming market town in the Yorkshire Wolds and its proximity to Scarborough, Hull and York makes it popular with commuters.

The town was host to a junction that saw the main line arrive from Bridlington and depart to Market Weighton and Selby. One branch headed south to Beverley and Hull and the other meandered across the Yorkshire Wolds to Malton. The stations en route had names like Sledmere & Fimber and North Grimston. Some of the branch buildings survive but the line was an early pre-Beeching casualty. Only the Hull to Bridlington route survives.

Driffield signal box is 19 miles and 26 chains (31.1 km) from Hull Paragon station.

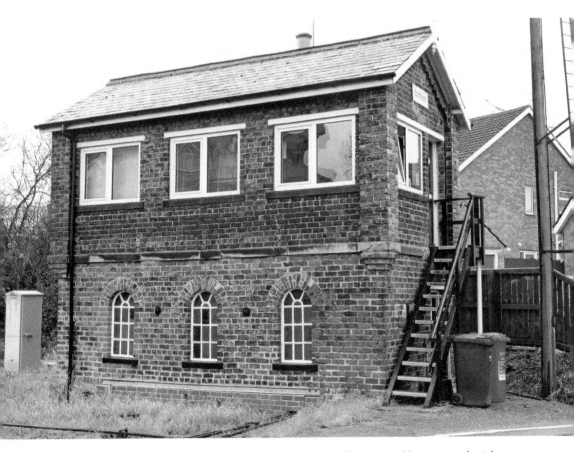

Fig. 112. The three levers in the box are for the mechanically operated barriers and wicket gates. The IFS panel handles the trains. The box is now so heavily modernised as to be unlikely to seem as old as it is. The point rodding is there to service a trailing crossover and engineer's siding. (December 2015).

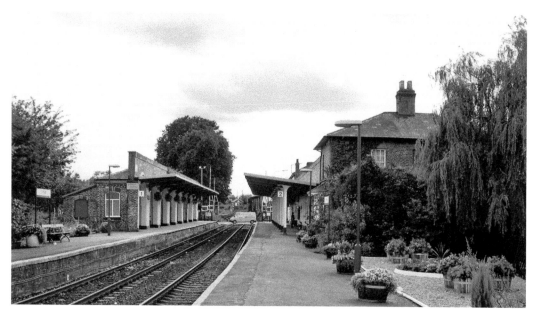

Fig. 113 is Driffield station and, unusually for this line, the overall roof was cut back to the two platform canopies on view. There is some of the LNER concrete garden edging and inside the vegetation is a base for a steam-age water tower. (August 2004).

Beverley Station (BS)

Date Built	NER Type or Builder	No. of Levers and/or Panel	Ways of Working	Current Status 2015	Listed Y/N
1911	NER Type S4	20	AB	Active	Y

The town of Beverley largely escaped the depredations of Second World War bombing, while nearby neighbour Hull was in the thick of it. Consequently, the Minster and surrounding town survives intact. One notable feature is the Beverley Bar, a fifteenth-century gate that required East Yorkshire Bus Company to design and build special double-decker buses that would fit under the gate. This is a kind of bus equivalent of the Burry Port & Gwendraeth Valley Railway in South Wales. Beverley is a starting point for Hull Trains services to London.

The station had been a junction with the York to Market Weighton to Hull line coming in from the north, but this was closed in the 1960s. Kipling Cotes was a minor station on the line and this survives almost intact down to station buildings, platforms, signal box and goods shed, but not track.

Beverley Station signal box is 8 miles and 20 chains (13.28 km) from Hull Paragon station.

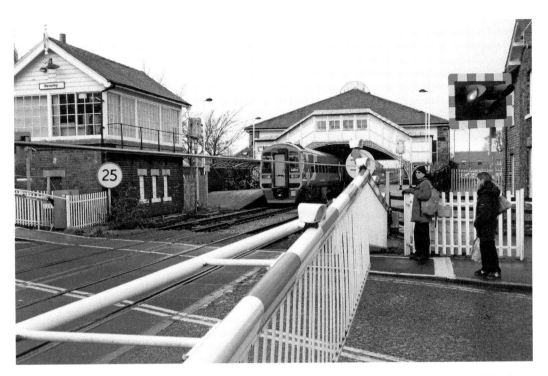

Fig. 114 illustrates Beverley Station signal box with barriers rising after the arrival of Northern Rail class 158 No. 158872 from Hull. (December 2015).

Fig. 115 is another of GT Andrews' train sheds with a suitably splendid portico and offices out of shot on the right. The station was listed in 1985. The signal in the foreground between the tracks is a device that allows a train that has come in from Hull to depart from the same platform without crossing over to the Up platform to depart. (August 2004).

WEST YORKSHIRE

The schematic not-to-scale diagram at Fig. 116 shows the NER in west Yorkshire and it consists of odd signal boxes retained essentially because they were and are doing a job, but not necessarily in a joined-up route like the other journeys. The Midland, Lancashire & Yorkshire, Great Northern, and Great Central railways all had a piece of the Yorkshire coal field, and the NER was really on the periphery of most of it. There was virtually no mechanical signalling left at the survey dates.

The journey starts in the east on the outskirts of Selby and the gate boxes on the ECML, and then goes west to end up in Castleford.

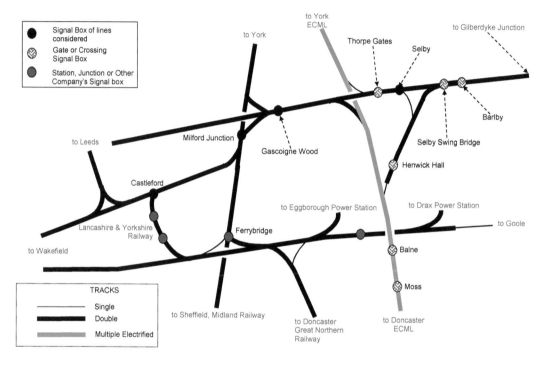

Fig. 116. West Yorkshire.

Barlby (–)

Date Built	NER Type or Builder	No. of Levers and/or Panel	Ways of Working	Current Status 2015	Listed Y/N
1898	NER Type S1A	7	Gate	Active	N

Barlby, near Selby, is most notable for the BOCM Pauls cattle cake mills. The line to the right of the signal box is to Gilberdyke Junction and the train depicted at Fig. 12 has passed Barlby on its way.

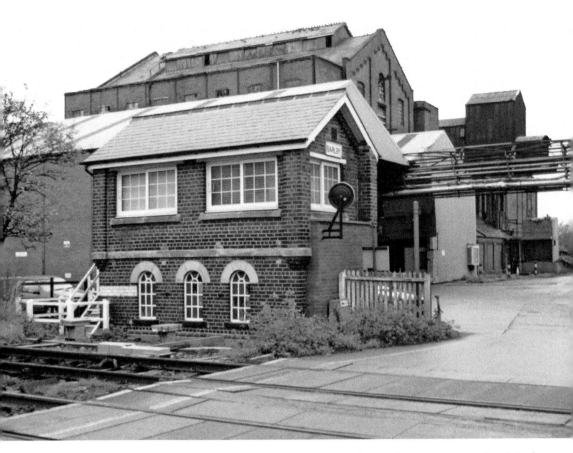

Fig. 117 shows Barlby signal box in good condition with wooden staircase and original locking frame windows. There is a pair of goods loops here and a goods yard on the Up side from the Hull direction owned by the Potter Logistics Group, who uses Selby as its northern rail hub. The road crossing is known as Olympia crossing after the BOCM Pauls works. (October 2006).

Barlby signal box is 30 miles and 34 chains (48.96 km) from the buffer stops at Hull Paragon station.

Selby Swing Bridge (–)

Date Built	NER Type or Builder	No. of Levers and/or Panel	Ways of Working	Current Status 2015	Listed Y/N
1891	NER Non Standard	Ground Frame and 2 IFS panels	Gate	Active	N

Selby was a junction on the ECML until it was bypassed in 1983.

Selby Swing Bridge signal box is 30 miles and 70 chains (49.69 km) from the buffer stops at Hull Paragon station.

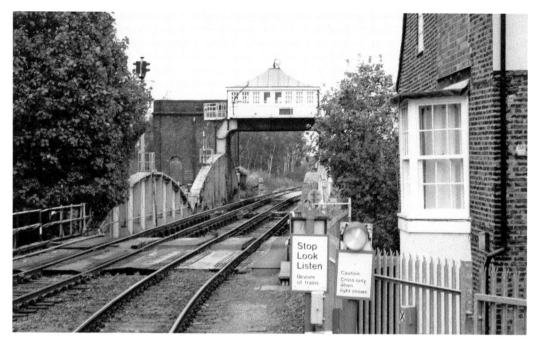

Fig. 118 shows the swing bridge from the end of a platform at Selby station and the view is towards Gilberdyke Junction. The bridge is operated hydraulically and the building on the left of the bridge and box is the hydraulic accumulator reservoir, which acts as a kind of battery for stored hydraulic energy.

The signal box element operates one IFS panel for the hydraulics the other for a semaphore distant signal for shipping coming downriver towards Hull. The frame operates the bridge bolt. Note the traffic light type indicators for shipping. (October 2006).

Fig. 119 is a view of Selby station towards the bridge and box. The bushes in the centre of the picture disguise the location of the ECML when it ran through here. The First TransPennine class 185 heading for Hull has just entered the next track section, and so tripped the home signal to danger behind the train. (October 2006).

Selby (S)

Date Built	NER Type or Builder	No. of Levers and/or Panel	Ways of Working	Current Status 2015	Listed Y/N
circa 1870	NER Type S1	NX Panel	TCB	Active	N

Selby signal box now controls much of the Selby area and a good many crossings in the local area. It also provides the release for Selby Swing Bridge, without which the bridge cannot operate.

The mileage changes now and Selby signal box is 40 chains (0.8 km) from Selby South Junction, which is itself 31 miles 12 chains (50.13 km) from the buffer stops at Hull Paragon station.

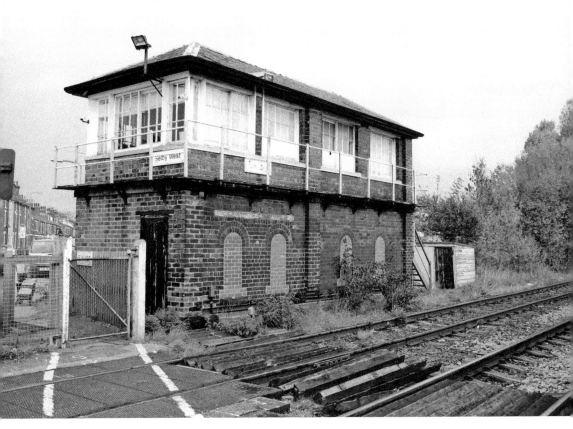

Fig. 120. Selby signal box retains its LNER-granted name of Selby West. (November 2006).

Thorpe Gates (–)

Date Built	NER Type or Builder	No. of Levers and/or Panel	Ways of Working	Current Status 2015	Listed Y/N
circa 1873	NER Type S1	IFS Panel	Gate	Demolished 2013	N

Thorpe Gates signal box was 2 miles 27 chains (3.76 km) from Selby South Junction.
The journey now diverges south towards the ECML.

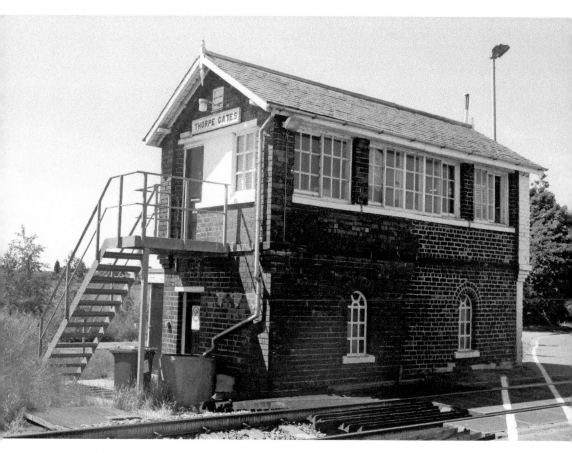

Fig. 121 and Thorpe Gates is showing evidence of the 1907 extension over 100 years later, together with a white painted end, presumably to avoid pedestrians walking into the end of the box at night. The nameplate on the steps end is of LNER vintage. The three triangles on the brickwork by the down pipe from the front gutter are evidence of fire bucket presence. There was a massive chimney stack at the rear of the box but this had been blanked off after the installation of propane gas heating. (June 2009).

Henwick Hall (–)

Date Built	NER Type or Builder	No. of Levers and/or Panel	Ways of Working	Current Status 2015	Listed Y/N
1912	NER Type S1b	IFS Panel	Gate	Closed 2014	N

Henwick Hall signal box is 172 miles and 20 chains (277.2 km) from Kings Cross station.

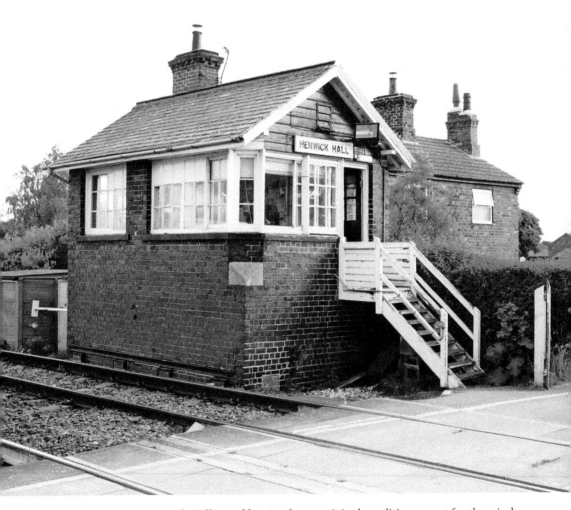

Fig. 122 illustrates Henwick Hall signal box in almost original condition except for the windows. An unusual feature is a TV aerial attached to the chimney stack. There is a piece of bull head rail let into the brickwork and this acts as a lintel for the rodding tunnel that was bricked up in 1972 when the mechanical signalling was removed. (June 2008).

Balne (–)

Date Built	NER Type or Builder	No. of Levers and/or Panel	Ways of Working	Current Status 2015	Listed Y/N
1957	BR North Eastern Region Type 17	IFS Panel	Gate	Closed 2014	N

Balne signal box is 165 miles and 71 chains (266.97 km) from Kings Cross station.

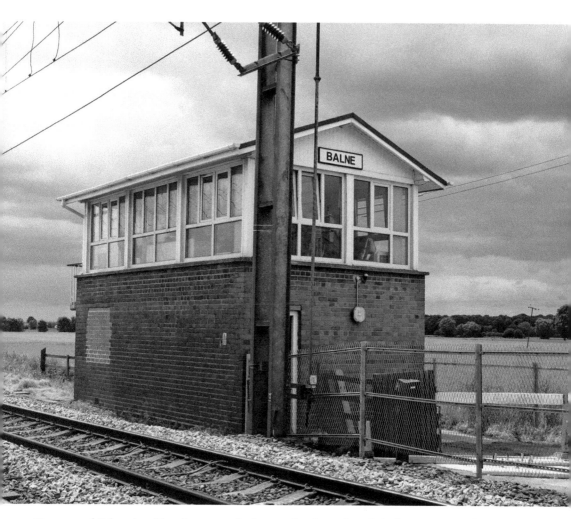

Fig. 123 and Balne signal box just controls the crossing here, though in former years it had been a block post and had a station and goods yard until 1958. (June 2008).

Moss (–)

Date Built	NER Type or Builder	No. of Levers and/or Panel	Ways of Working	Current Status 2015	Listed Y/N
1873	NER Type S1a	IFS Panel (TEW)	Gate	Closed 2014	N

Moss signal box is 163 miles and 2 chains (262.36 km) from Kings Cross station.

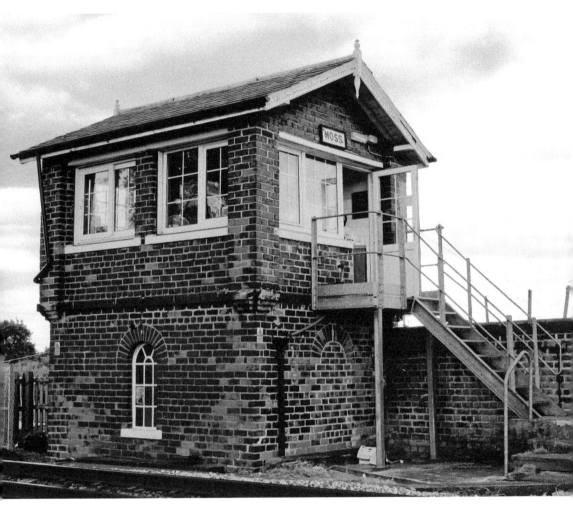

Fig. 124 shows Moss in fairly original condition. Locking frame windows are rare survivors, as most are bricked up for security reasons. Underneath the steps there had been another window. The plasticised plumbing pipes are not simpatico with the original fittings. (June 2008).

Milford (M)

Date Built	NER Type or Builder	No. of Levers and/or Panel	Ways of Working	Current Status 2015	Listed Y/N
1958	BR North Eastern Region Type 17	NX Panel	TCB	Active	N

Milford is a large junction and was a coal mining and power station hub.

Milford signal box is 14 miles and 71 chains (23.96 km) from York and 7 miles and 49 chains (12.25 km) from Selby South Junction.

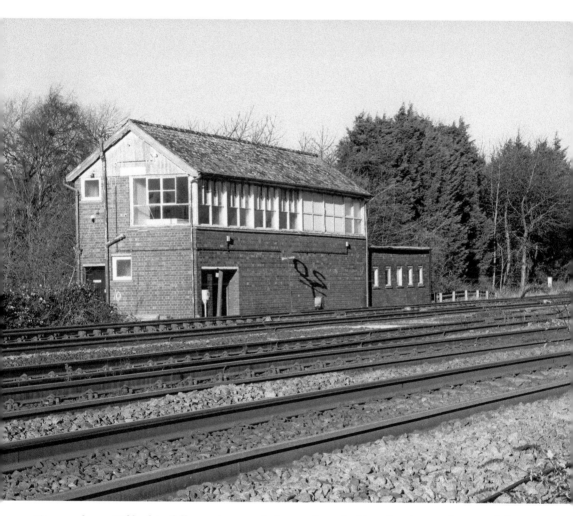

Fig. 125 shows Milford in fully modern mode but perhaps lacking the charm of some of the pre-grouping structures. (December 2015).

Fig. 126 illustrates the track environment at Milford but from the opposite end of the layout from the previous figure. The shot from the Common Lane over bridge shows Milford signal box on the right with the quadruple-tracks from the south and west coming in at the top of the picture. A yard with coal hoppers is on the left and there is a double-track line that goes the short distance to Gasgoigne Wood signal box and Gilberdyke Junction. The sidings on the right are full of Biomass wood chip hoppers. There are two goods loops either side of the two straight running tracks. (December 2015).

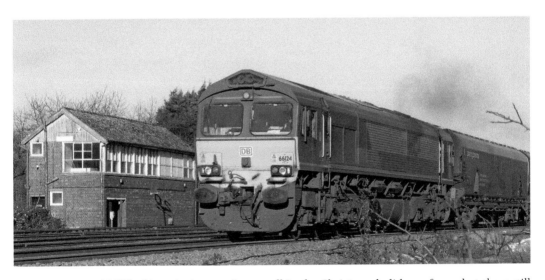

Fig. 127 and Milford is enjoying a quieter spell in the Christmas holidays of 2015 but there still lies the requirement to feed the power station beast. EWS-branded class 66 No. 66124 heads a train of Drax Biomass Hopper wagons southwards towards Ferrybridge and Drax power station. Each wagon is 102 tonnes Gross Laden Weight (GLW) and there were 24 wagons in the train making a total – if all wagons are fully loaded – of 2,448 tonnes. (December 2015).

Fig. 128 shows No. 66112 shunting in the yard of the sidings rather than loops. The Milford Curve is on the extreme left and the former Selby colliery building, which is now a recycling plant, is on the extreme right. (December 2015).

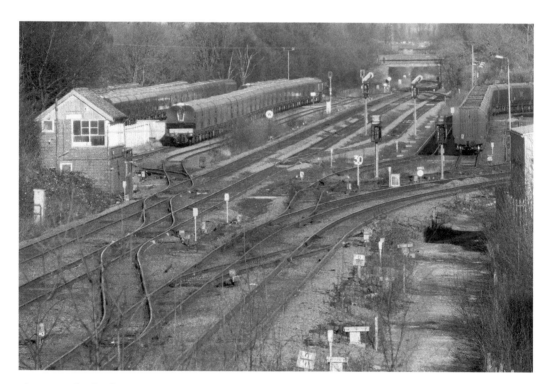

Fig. 129 is the final view at Milford with the two tracks to Wakefield and Leeds right by the box and a series of crossovers to enable trains to switch to the nearer Ferrybridge pair of tracks. The Milford Curve sweeps around to the right to continue to Gascoigne Wood and Gilberdyke Junction. (December 2015).

Gascoigne Wood (GW)

Date Built	NER Type or Builder	No. of Levers and/or Panel	Ways of Working	Current Status 2015	Listed Y/N
1908	NER Type S4	NX Panel	TCB	Active	N

The tracks in the foreground are the direct connection from Gascoigne Wood mine yard to Milford yard, so are looking disused. The Milford Curve has already joined the Leeds to Hull line before this point.

Gascoigne Wood signal box is 14 miles and 30 chains (23.13 km) from York and 6 miles and 27 chains (10.2 km) from Selby South Junction.

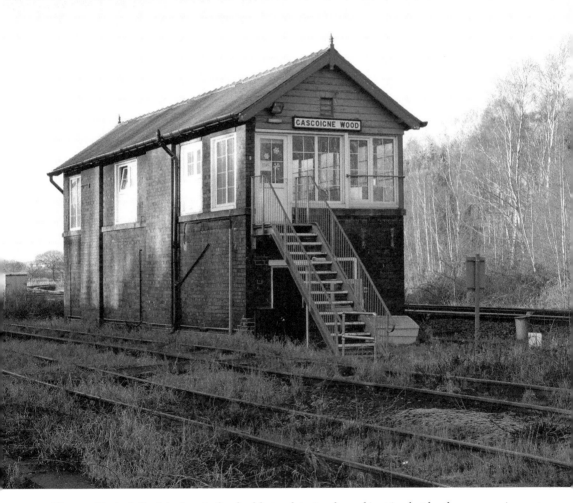

Fig. 130. To the left of the box is the double-track to Leeds, and just in shot by the grey equipment cabinet is the line curving away north to York. The tracks on the far side of the signal box on the right head for Gilberdyke Junction and Hull. (December 2015).

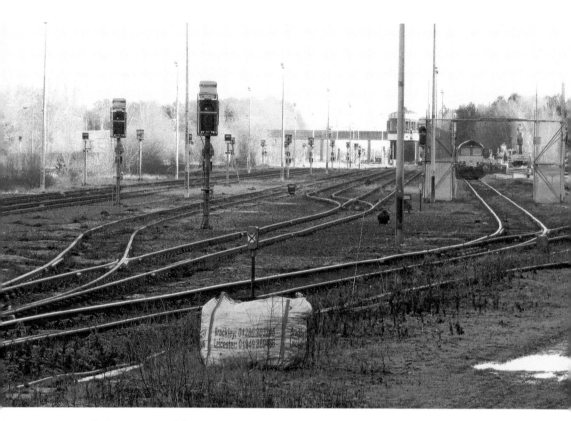

Fig. 131 is a little way east of the Gascoigne Wood signal box and the Leeds Hull line on the left with the camera pointing towards Hull. The Gascoigne Wood mine sidings and loops are on the right and the class 66 would seem to be on a disposal mission with the aggregate and digger equipment in the background. The mine control panel or signal box can be seen to the left of the class 66. (December 2015).

Castleford (CD)

Date Built	NER Type or Builder	No. of Levers and/or Panel	Ways of Working	Current Status 2015	Listed Y/N
1997	Portakabins	NX Panel	TCB	Active	N

Castleford was a junction with the Lancashire & Yorkshire Railway.

Castleford signal box is 21 miles and 22 chains (34.22 km) from York.

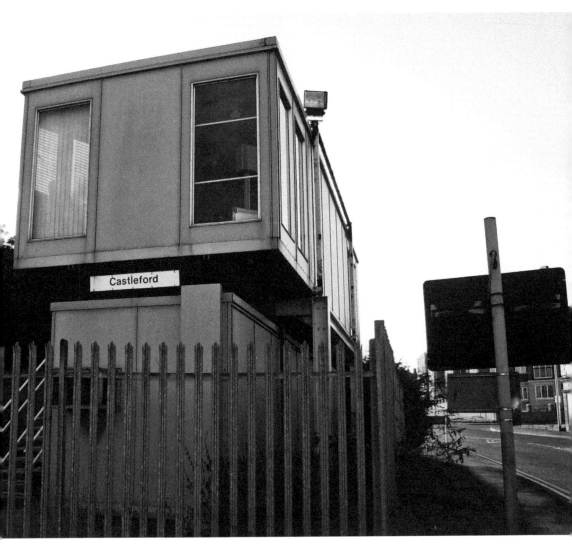

Fig. 132 is Castleford signal box, a late replacement for four signal boxes: Castleford Gates (NER), Methley Junction (Midland Railway), Whitwood (NER) and Altofts Junction (Midland Railway). Castleford Gates is a listed building and still in place, as is the Castleford Station signal box, both being NER types. The present box controls its road barriers from a pedestal control panel, as can be seen in the window. (December 2008).

References and Acknowledgements

Acknowledgements

The kindness and interest shown by railway staff.

References

Books and Printed Works

Signalling Atlas and Signal Box Directory – Signalling Record Society

Quail Track Diagrams Parts 2 and 4 – TrackMaps

British Railways Pre-Grouping Atlas and Gazetteer – Ian Allan

Red for Danger (L.T.C. Rolt) – Pan Books

Internet Websites

Adrian the Rock's signalling pages:
http://www.roscalen.com/signals

The Signalbox – John Hinson:
www.signalbox.org/

Wikipedia
http://signalboxes.com/
http://www.pastscape.org.uk/hob.aspx?hob_id=499039
https://www.flickr.com/photos/driff_tiger/5887900348/in/photostream/